The ARCADES: Contemporary Art and Walter Benjamin

Convoluted by
Jens Hoffmann
with contributions by
Caroline A. Jones
Vito Manolo Roma
and
Kenneth Goldsmith

The Jewish Museum, New York
Under the auspices of the
Jewish Theological Seminary of America

Yale University Press
New Haven and London

Donors to the Exhibition

The Arcades: Contemporary Art and Walter Benjamin is made possible by the Edmond de Rothschild Foundations, the Goldie and David Blanksteen Foundation in memory of David Blanksteen, and the Graham Foundation for Advanced Studies in the Fine Arts.

Additional support is provided by the Melva Bucksbaum Fund for Contemporary Art, the Barbara Horowitz Contemporary Art Fund, the Jewish Museum Centennial Exhibition Fund, the Alfred J. Grunebaum Memorial Fund, and the Leon Levy Foundation.

Lenders to the Exhibition

Alka and Ravin Agrawal
Arratia Beer, Berlin
Walter Benjamin Archiv,
 Akademie der Künste, Berlin
Walead Beshty
Bjørnholt Collection, Oslo
Chris Burden Estate
Bureau, New York
Callicoon Fine Arts, New York
Colleción Isabel y Agustín Coppel
 (CIAC), Mexico City
Haris Epaminonda and
 Daniel Gustav Cramer
Fisher Collection, San Francisco
Claire Fontaine
Fraenkel Gallery, San Francisco
Gagosian
Marian Goodman Gallery, New York
Galerie Max Hetzler, Berlin
Hill Gallery, Birmingham,
 Michigan

Collection Inhotim, Brumadinho,
 Brazil
Kadist, San Francisco
Sanya Kantarovsky
Mike Kelley Foundation
 for the Arts
Lisson Gallery, London
Luhring Augustine, New York
Mor Charpentier, Paris
Museum of Contemporary Art,
 Detroit
Adam Pendleton
Galerie Perrotin, Paris
Rennie Collection, Vancouver,
 British Columbia
Galerie Thaddaeus Ropac, Paris
Cynthia and Abe Steinberger
Wadsworth Atheneum, Hartford
Wentrup, Berlin
White Cube, London
John and Barbara Wilkerson

Artists in the Exhibition

Erica Baum
Walead Beshty
Milena Bonilla
Andrea Bowers
Nicholas Buffon
Chris Burden
Haris Epaminonda and
 Daniel Gustav Cramer
Simon Evans
Walker Evans
Claire Fontaine
Lee Friedlander
Rodney Graham
Andreas Gursky
Raymond Hains
Pierre Huyghe
Voluspa Jarpa
Jesper Just
Sanya Kantarovsky
Mike Kelley
Tim Lee
Jorge Macchi
Adam Pendleton
Martín Ramírez
Bill Rauhauser
Mary Reid Kelley
Ry Rocklen
Markus Schinwald
Collier Schorr
Cindy Sherman
Taryn Simon
Joel Sternfeld
Mungo Thomson
Timm Ulrichs
James Welling
Guido van der Werve
Cerith Wyn Evans

Contents

37 Convolutes
 Annotations by Kenneth Goldsmith

A Arcades, *Magasins de Nouveautés*, Sales Clerks
B Fashion
C Ancient Paris, Catacombs, Demolitions,
 Decline of Paris
D Boredom, Eternal Return
E Haussmannization, Barricade Fighting
F Iron Construction
G Exhibitions, Advertising, Grandville
H The Collector
I The Interior, The Trace
J Baudelaire
K Dream City and Dream House, Dreams of the Future,
 Anthropological Nihilism, Jung
L Dream House, Museum, Spa
M The Flâneur
N On the Theory of Knowledge, Theory of Progress
O Prostitution, Gambling
P The Streets of Paris
Q Panorama
R Mirrors
S Painting, Jugendstil, Novelty
T Modes of Lighting
U Saint-Simon, Railroads
V Conspiracies, *Compagnonnage*
W Fourier
X Marx
Y Photography
Z The Doll, The Automaton
a Social Movement
b Daumier
d Literary History, Hugo
g The Stock Exchange, Economic History
i Reproduction Technology, Lithography
k The Commune
l The Siene, The Oldest Paris
m Idleness
p Anthropological Materialism, History of Sects
r École Polytechnique

Foreword

Walter Benjamin was one of our most perceptive observers of society, and it is only natural to wonder what he would make of our time. *The Arcades: Contemporary Art and Walter Benjamin* connects Benjamin's unfinished, kaleidoscopic opus *The Arcades Project* to contemporary artworks and poetic annotations that illustrate and elucidate his ideas.

Benjamin was fascinated by urban life. He worked on his exploration of Paris's nineteenth-century urban milieu for more than a decade, leaving it unfinished at the time of his suicide in 1940. Now, this book and exhibition transport Benjamin's work from the world of nineteenth-century Paris to twenty-first-century New York, refracting his insights on urban life through the lenses of art and writing today.

The Arcades: Contemporary Art and Walter Benjamin recreates the experience of the flâneur, with visitors and readers encountering ideas, themes, and urban characters seemingly by chance. Just as a flâneur roams the city with no particular purpose in mind other than to indulge in the act of observing, this book and exhibition are nonlinear in structure, encouraging wandering and serendipitous discoveries. Kenneth Goldsmith's wonderful poetry, composed from found and appropriated texts, likewise mimics the experience of an urban stroll, substituting language itself for the city's streets.

Benjamin's relentless questioning—of established truths, and of the very foundations of modernity itself—was quintessentially Jewish, and his outsider's perspective on contemporary life no doubt honed the sharpness of his observational powers. With his probing intellect and his interest in urban life, an exploration of The Arcades Project is a perfect fit for the Jewish Museum, and I am grateful to the many people who contributed to the success of this exhibition and publication, especially the Edmond de Rothschild Foundations, for their continued partnership and leadership support.

We extend our gratitude to the wonderful and talented staff at the Jewish Museum for all their hard work. Jens Hoffmann, Director of Special Exhibitions and Public Programs, produced a unique and marvelous project, ably supported by Shira Backer, Leon Levy Curatorial Associate. Crucial assistance was also provided by Ruth Beesch, Deputy Director, Program Administration, and Norman Kleeblatt, Susan and Elihu Rose Chief Curator. Thanks to Elyse Buxbaum and her team for securing the necessary funding, and to our marketing and communications team for spreading the word. I also extend my gratitude to David Goldberg and Sabina Avanesova in the Director's Office. Al Lazarte, Senior Director of Operations and Exhibition Services, and his staff expertly installed the exhibition. The innovative design is by Project Projects. Lindsey Westbrook edited this book with care and discernment, aided by Eve Sinaiko, Director of Publications.

Private collectors and institutions have been generous with loans, and we offer them our heartfelt gratitude. As always, the Jewish Museum is sustained by the enthusiastic support of its Trustees, under the capable leadership of Board Chairman Robert A. Pruzan and President David L. Resnick.

Claudia Gould
Helen Goldsmith Menschel Director
The Jewish Museum

8

Acknowledgments

We are most grateful to all the participating artists, without whom such an ambitious project would not have been possible: Erica Baum, Walead Beshty, Milena Bonilla, Andrea Bowers, Nicholas Buffon, Chris Burden, Haris Epaminonda and Daniel Gustav Cramer, Simon Evans, Walker Evans, Claire Fontaine, Lee Friedlander, Rodney Graham, Andreas Gursky, Raymond Hains, Pierre Huyghe, Voluspa Jarpa, Jesper Just, Sanya Kantarovsky, Mike Kelley, Tim Lee, Jorge Macchi, Adam Pendleton, Martín Ramírez, Bill Rauhauser, Mary Reid Kelley, Ry Rocklen, Markus Schinwald, Collier Schorr, Cindy Sherman, Taryn Simon, Joel Sternfeld, Mungo Thomson, Timm Ulrichs, James Welling, Guido van der Werve, and Cerith Wyn Evans.

We would also like to thank the individuals, institutions, and galleries who helped to make this exhibition: Kathryn Erdman and 303 Gallery; Noreen Ahmad; Alice Conconi and Liz Mulholland of Andrew Kreps Gallery; Kathryn Andrews; Richard Armstrong; Euridice Arratia and Arratia Beer; Aimée Dubos-Chantemesse of the Association des Passages & Galeries; Aurelie Paradiso and Aurelie Paradiso Design; Tracey Bashkoff; Pascale Berthier; Valérie Alonzo and the Bibliothèque de la Ville de Paris; Fred Bidwell; Francesco Bonami; Edoardo Bonaspetti; Elysia Borowy-Reeder; Gabrielle Giattino and Mary Grace Wright of Bureau; Photios Giovanis and Callicoon Fine Arts; Fulvia Carnevale and James Thornhill; Veronica Levitt and Loring Randolph of Casey Kaplan Gallery; Carolyn Christov-Bakargiev; David Nolan Gallery; Okwui Enwezor; Claire Morgos and Feuer/Mesler; Abner Nolan and the Fisher Collection; Harrell Fletcher; Frish Brandt, Jeffrey Fraenkel, and Tiffany Harker of Fraenkel Gallery; Louise Neri and Gagosian Gallery; Massimiliano Gioni; Liz Glass; Michelle Grabner; Stacen Berg and Timo Kappeller of Hauser Wirth & Schimmel; Cora Hansen and Guillaume Benaich of Galerie Max Hetzler; Tim and Maggie Hill of Hill Gallery; the Hirshhorn Museum and Sculpture Garden; Maria and Federico Hoffmann; Sophia Hoffmann; Fernanda Arruda and Collection Inhotim; Mary Jane Jacob; David Norr and Emily Ruotolo of James Cohan Gallery; Devon Bella and Alex Matson of the Kadist Art Foundation; Michelle Kuo; José Kuri; Luisa Lambri; Pablo León de la Barra; Lawrence Luhring, Roland Augustine, and Natalia Sacasa of Luhring Augustine Gallery; Luisa Strina and Galeria Luisa Strina; Yves Bozelec, Frédérique Gerardin, and Mathias Vicherat of the Mairie de Paris; Monica Manzutto; Marc Foxx Gallery; Roxana Marcoci; Rose Lord and Marine Pariente of Marian Goodman Gallery; Liza McLaughlin; Metro Pictures; Marsha Miro; Philippe Charpentier and Alex Mor of Mor Charpentier; Jessica Morgan; the Museum of Modern Art; Julian Myers-Szupinska; Pace Gallery; Daniel Palmer; Adriano Pedrosa; Emmanuel Perrotin and Galerie Perrotin; Courtney Plummer; Heidi Rabben; Shaun Caley Regen and Jennifer Loh of Regen Projects; Wendy Chang and Erin Watkins of the Rennie Collection; Frank Maresca and Roger Ricco of Ricco Maresca Gallery; Andrea Rollefson; Andrea Rosen; Jessica Silverman; the Solomon R. Guggenheim Museum and Foundation; Lisa Spellman; Kim Klehmet and Sprüth Magers; Emily Sundblad; Julia Reyes Taubman; Thomas Dane of Thomas Dane Gallery; Susanne Vielmetter; Ursula Marx and Erdmut Wizisla of the Walter Benjamin Archiv; Steffi Haferbeck and Nico Anklam of Wentrup Gallery; Joyce Lau and White Cube; Vincent Worms; and Yvon Lambert.

Thanks to the following individuals at the Jewish Museum who have tirelessly worked on this exhibition: Shira Backer, Leon Levy Curatorial

9

Associate; Ruth Beesch, Deputy Director, Program Administration; Grace Astrove, Development Officer for Exhibitions; Sabina Avanesova, Executive Assistant and Coordinator of Special Projects; Jennifer Ayres, Exhibitions Manager; Nelly Silagy Benedek, Director of Education; Marissa Berg, Director of Visitor Experience; Elyse Buxbaum, Director of Development; Olivia Blakely Caswell, Associate Registrar for Exhibitions; JiaJia Fei, Director of Digital; David Goldberg, Chief of Staff; Michelle Humphrey, Rights and Reproduction Coordinator; Norman Kleeblatt, Susan and Elihu Rose Chief Curator; Marisa Kurtz, Curatorial Department Coordinator; Amelia Kutschbach, Curatorial Assistant for Publications; Al Lazarte, Senior Director of Operations and Exhibitions Services; Julie Maguire, Senior Registrar; Julie Reiter, Marketing Coordinator; Anne Scher, Director of Communications; Eve Sinaiko, Director of Publications; Sarah Supcoff, Deputy Director, Marketing and Communications; Jenna Weiss, Manager of Public Programs; Stacey Zaleski, Director of Merchandising; Sophia Inkeles and Michael Neumeister, interns; and the rest of the museum's curatorial team.

Very special thanks go to Kenneth Goldsmith for a most illuminating collaboration and his incredible sense of humor; to Vito Manolo Roma for the most wondrous and striking illustrations; to Caroline A. Jones for her razor-sharp and astute essay; and to Prem Krishnamurthy, Max Harvey, and Lucas Lind for the astonishing design of this publication.

Our deepest gratitude goes to Claudia Gould, Helen Goldsmith Menschel Director of the Jewish Museum. Without her support and encouragement *The Arcades: Contemporary Art and Walter Benjamin* would not have been possible.

This exhibition and publication are dedicated to the restless and visionary mind of Walter Benjamin (1892–1940).

Jens Hoffmann
Director of Special Exhibitions and Public Programs
The Jewish Museum

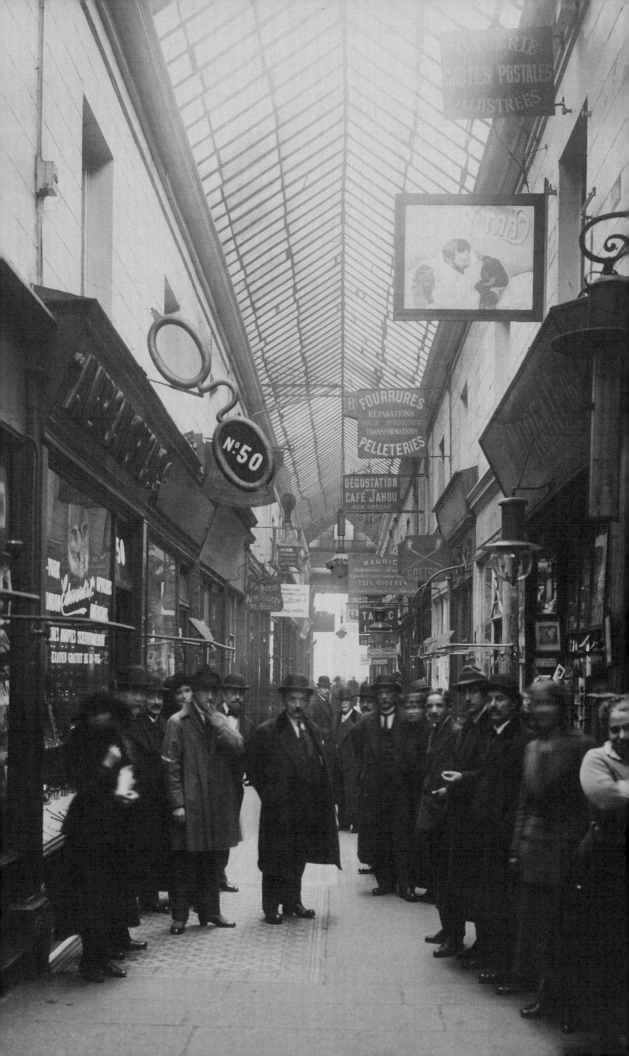

The Return of the Flâneur
Jens Hoffmann

> In the fields with which we are concerned, knowledge
> comes only in lightning flashes. The text is the long roll
> of thunder that follows.
>> Walter Benjamin,
>> *The Arcades Project*, Convolute N

Given the ever-growing cult around the German Jewish philosopher, literary critic, and cultural commentator Walter Benjamin (1892–1940), it is not surprising that a number of recent endeavors have attempted to tackle his legacy in novel and unusual ways. Why does Benjamin continue to occupy our minds? What makes his writings so persistently attractive as a means of understanding the world, more than seventy years after his death?

Apart from the immediate period after his passing, Benjamin has hardly been overlooked and certainly never forgotten. Ever since the publication of his first major volume of selected essays, *Writings* (1955, edited by Theodor Adorno), fifteen years after he committed suicide on the French-Spanish border while trying to escape the Nazis, he has been a seminal figure in the academic canon of literary criticism and cultural studies. A fuller appearance of his thoughts in the Anglophone world was delayed until the publication of the first English anthologies in 1968 and 1978, and then the considerable four-volume *Selected Writings*, published between 1996 and 2003, which allowed for a full, in-depth examination of his texts.

Benjamin is widely regarded as one of the most astute witnesses of early European modernity, who despite his early demise left behind a massive body of work that is as diverse as it is unique. His essays touch on a wide range of topics, from children's literature to pornography, cinema, travel, folk art, toys, gambling, and much more. His writing style is equally idiosyncratic, floating between fiction, poetry, reportage, cultural critique, and personal memoir. His recollection of his upbringing in an upper-middle-class Jewish household on the threshold between the nineteenth and the twentieth centuries, titled *Berlin Childhood around 1900* (written between 1932 and 1938 and unpublished during his lifetime), is now considered a masterpiece of modern literature, melding an examination of individual memory and everyday life with a much larger historical context. His discursive essay "The Work of Art in the Age

of Mechanical Reproduction" (1936) has had an immense influence on media studies, art history, and our overall understanding of the role and function of the art object in modern capitalist society. And it continues to have enormous relevance in our contemporary era, in which technological developments, particularly in the field of digital and social media, are resulting not just in information and sensory overstimulation, but in massive social transformations that we are only beginning to identify and understand.

Walter Benjamin's library card for the Bibliothèque Nationale, Paris, 1940

What is peculiar about the Benjamin renaissance is that many of his key observations are not of particular relevance for how we examine and experience life today. As a Marxist, Benjamin looked at the world as the outcome of economic structures and forms of production. His thoughts on art, authenticity, and the aura (best described as the supernatural force that arises out of an artwork's uniqueness) are connected to that. All three—art, aura, and authenticity—experienced much further deliberation in the decades that followed, and most of Benjamin's views on these topics have come to be demystified and now seem outdated. Thus it is not so much Benjamin's specific theoretical hypotheses that are responsible for the resurrection of his renown, but more his distinctiveness as a thinker among the writers, academics, and artists who constituted his milieu.

Benjamin's cohort, who emerged during the Weimar period—a brief moment of cultural flourishing in Germany that followed the catastrophe of World War I, and then vanished into the even greater catastrophe of the Third Reich—included Bertolt Brecht, Theodor W. Adorno, Max Horkheimer, Karl Mannheim, Ernst Bloch, Edmund Husserl, Hannah Arendt, Herbert Marcuse, Siegfried Kracauer, and Erich Fromm, to mention only a few. Benjamin knew personally, admired, and even collaborated with many of them. They in turn had descended from an earlier group of ideological fathers that included Georg Lukas, Franz Kafka, Gershom Scholem, Charles Baudelaire, and (most important for Benjamin) Karl Marx.

Among all of these, Benjamin stands apart for his prose, which is equally complex and accessible, combining intricate philosophical thoughts with an immediacy, transparency, and personal tone that keeps the reader engaged as much on an intellectual level as on a pleasurable one. Rather than offering a complete, coherent, uniform system of ideas, his is a fragmented, unfinished, open, and sometimes even contradictory project, seemingly inviting us to finalize his considerations and reflections from our own point of view. He does not set down a linear narrative or a rigorous ideological structure, or even attempt to predict the future developments of humankind (see his brief but significant text "On the Concept of History," written just before his

13

Walter Benjamin's indices of motifs from *The Arcades Project* for use in a planned book on Baudelaire, 1937; left to right: The Flâneur and the Masses, Wares, Development, Chthonic Paris
Walter Benjamin Archiv, Akademie der Künste, Berlin

death in 1940, for a sharp critique of Marx and Engels's idea of historical materialism), but lays bare the subtle yet profound relations and ambiguities that sit underneath the skin of the modern world. His love of allegories, his affection for obscure facts and uncommon pieces of knowledge, and his fascination with montage all resonate with how humanity sees and reflects upon itself today. In his writings, Benjamin seems to acknowledge the impossibility of universal truth, and embraces everyday disorder and confusion with a deeply human touch. He is never overbearing, never pompous, but always poetic, graceful, and to some degree tenuous, indefinite. Within the intensity of his prose and the exhaustiveness of his observations lies also an enormous vulnerability that still rings true in the twenty-first century. His writings express a dark and almost apocalyptic prophecy, and yet they reveal the vital sensibility of a positive and utopian spirit.

The circumstances of Benjamin's death have without a doubt contributed to the mythos that surrounds him, as his demise was not only a personal tragedy but a metaphor for the end of one of modernism's most vital

439

473

and unique manifestations, the intellectual world of the Weimar Republic. The romantic conception of him as a tragic genius is further fueled by the unfortunate events of his life: he was denied a proper academic career after having his thesis on the origin of the German tragic drama (*Ursprung des deutschen Trauerspiels*) informally rejected by Goethe University in Frankfurt (the faculty, including Max Horkheimer, deemed the text impenetrable and not adhering to the conservative academic standards of its time), and he lived in utter destitution for most of his adult life. Most of his major essays were unpublished at the time of his death.

The details of Benjamin's suicide by a massive overdose of morphine in the Spanish border town of Portbou are exquisitely explored in Michael Taussig's intriguing book *Walter Benjamin's Grave*, for which the author traveled to Portbou to retrace Benjamin's final hours. He describes his visit to the cemetery to look for the (unmarked) grave, and gathers eyewitness accounts of the situation surrounding the writer's demise. What is perhaps less germane to an understanding of Benjamin's relevance today, but still an important fact,

The first page of Benjamin's manuscript for the second *Paris Letter*, 1936
Walter Benjamin Archiv, Akademie der Künste, Berlin

is that many other Jewish intellectuals, political activists, writers, and artists committed suicide rather than be captured by the Nazis, something that Taussig touches upon in his book.

Upon his departure from Paris, shortly before the invasion of the German troops, Benjamin entrusted his friend, the French writer and intellectual George Bataille, with the unfinished manuscript of what was going to be his magnum opus, the *Passagenwerk* or *Arcades Project*. At that stage, it was still an enormous and unwieldy collection of texts, mostly written between 1927 and 1940. Bataille hid it in the Bibliothèque Nationale in Paris, where he was then working as a librarian, and it was rediscovered after the war and posthumously published in a reconstructed format. *The Arcades Project* is thus by no means a finished book in the traditional sense, and perhaps was uncompletable because of its vast scope and convoluted composition. It is a mountainous montage of quotes, notes, sketches, reflections, citations, and commentaries on Paris's exuberant urban life; Benjamin's style of research ranged from scholarly work at archives and libraries to incidental observations of the everyday.

It is fair to say that almost all of Benjamin's writings from that period relate in one way or another to his exploration of the urban formation and condition of Paris, which he regarded as the world capital of the nineteenth century. In essence, *The Arcades Project* outlines how everyday objects of industrial culture have the ability to simultaneously function as anticipations of social utopias and as hints of a radical political critique of modern times. Benjamin's first steps on *The Arcades Project* included a short piece about Paris's nineteenth-century iron-and-glass vaulted shopping *passages*. Because of their labyrinthine architecture and surrealistic juxtapositions of past and present (Gothic cathedral meets modern construction), the arcades offered an ideal metaphor for the author to examine the era's capitalist metropolis. It was Benjamin's goal to philosophically understand metropolitan urbanity as he saw and experienced it.

Much has been said and written about *The Arcades Project.* Particularly fascinating, and now a classic in the interpretation of Benjamin, is Susan Buck-Morss's *The Dialectics of Seeing*, which explores the work's conceptual structure. In the estimation of Buck-Morss, the fact that Benjamin never got to "write" his masterpiece, that it remains fragmented, is somehow appropriate—in the end, it follows its own logic. Benjamin's inability to complete his work was a form of failure that was inescapable, even required, under the conditions of modernity he described; the structure of his highly unorthodox philosophical inquiry acknowledges and mirrors a necessarily fragmented and incomplete project of knowledge production and interpretation. Its incompleteness in fact might be its biggest strength and success. Reading this sprawling taxonomy of Vieux Paris and the modern city is a collagelike experience, not unlike the way we experience the Internet today. Indeed, Benjamin foreshadows the fragmented postmodern urban viewpoint brought about by globalization as well as social and digital media.

Two recent projects that continue the tradition of innovative exchange and dialogue with Benjamin's ideas, and are worth mentioning in trying to assess the latest fascination with his literary and philosophical output, are David Kishik's *The Manhattan Project* and Kenneth Goldsmith's ambitious and creative venture *Capital.* Kishik's book proposes a curious case of historical revisionism, taking as its premise the idea that Benjamin in fact survived. After crossing the border into Spain, he makes his way through the Pyrenees to Lisbon, from whence he takes a ship to the United States. He settles in New York, adopts a reclusive existence, gets a quiet job in the mail room of the *New York Daily Mail*, and secretly works on the sequel to his *Arcades Project*, which he titles the *Manhattan Project.* In the same passionate way in which he viewed Paris as the world capital of the nineteenth century, New York becomes Benjamin's new obsession—his global capital of the twentieth century—and he draws countless parallels between the two metropolises. (He eventually dies in obscurity in 1987 at the age of ninety-five.) Kishik's book is a fascinating piece of experimental philosophy and fiction in which the author examines the thoughts of an undead phantom. While the imaginary/real lens of the German writer is clearly the starting point, Kishik moves beyond (conjured) biography and offers his own inventive and original theory of New York's dense, energetic cultural and social realities.

In 2005 the American poet Kenneth Goldsmith began to undertake the epic task of (re)writing *The Arcades Project*, placing it, as Kishik did, in New York. His principal idea was to use Benjamin's methods as a structure for a new book that would analyze New York as the capital of the twentieth century. For him, New York, despite its magnitude, is a city still coming into its own, still processing its rapid development and growth, in contrast to Benjamin's Paris, a city with a history several centuries long. Yet the enormity of his project is hardly less than Benjamin's when we consider the massive quantity of literature that has taken New York as its subject. To create his thousand-page book, Goldsmith spent innumerable days accumulating quotes, notes, and citations from previously published texts on the city, which he located by wading through countless university and neighborhood public libraries as well as secondhand bookshops. His new and highly subjective portrait of the city uses in many cases Benjamin's same chapter headings (or, as Benjamin called them, Convolutes) to organize the text in a way that closely mirrors *The Arcades Project.* New Convolutes emerged out of the research as well, and are arranged under headings that are not too surprising: Restlessness, Fame, Ambition, and Consumerism, among others. Like Benjamin,

Goldsmith stresses the act of choosing what to look for—what to investigate and what to ignore and discard. The outcome is in many respects more a work of art than a traditional publication.

The exhibition and publication *The Arcades: Contemporary Art and Walter Benjamin* is a meditation on *The Arcades Project* and its ongoing relevance and importance. It forgoes a traditional linear narrative, instead mixing archival materials from the Walter Benjamin archive in Berlin, blueprints and architectural models of the Parisian arcades, and works of contemporary art in media ranging from photography to painting, sculpture, film, and video. In presenting a collection of incomplete fragments, the curatorial methodology follows Benjamin's own style of working in archives and libraries and creating textual collages (his written collages were not so unlike visual art's collage mode). This assemblage of many parts into an elaborate structure is intended to encourage viewers to look at our own moment via the author's prescient reflections. By transposing Benjamin's Paris to New York, it enables visitors to inhabit the role of the flâneur, Benjamin's archetypal leisured city dweller, the connoisseur of the street who saunters about town. Like those urban explorers, we may reorganize and reassemble the exhibition to suit our tastes as we circuitously wander through it. As in reading *The Arcades Project*, the experience results in countless juxtapositions and moments of simultaneity that produce unintended but meaningful significance in an otherwise fractured and fragmented world.

The project is organized according to thirty-six subjects, which are based on the Convolutes of *The Arcades Project*. Each convolute is represented by the work of one artist, or in some cases series of connected works. The materials from the Walter Benjamin Archive include pieces of the original manuscript for *The Arcades Project*, letters, notes, and sketches as well vintage photographs depicting Benjamin at work taken by the German-born French photographer Gisèle Freund. Another section looks at the history of the fin-de-siècle Parisian arcades. It presents scale models of the most significant arcades, including blueprints and floor plans, and a timeline outlining their development and construction.

Finally, the poet Kenneth Goldsmith has annotated the entire project. Drawing from his research for *Capital*, he selected thirty-six different texts to pair with artworks in the show, and these texts are presented physically in the galleries, and here in this book, alongside the relevant works.

The Arcades: Contemporary Art and Walter Benjamin is as much a reconsideration of Benjamin's *The Arcades Project*, his most important contribution to twentieth-century thought, as it is a curatorial experiment that understands the exhibition space as a microcosm of our neoliberal capitalist society. It is a coauthored space, in the sense that it is collaboratively and dynamically constructed anew by the visitor upon each viewing, and thus it proposes ways to upend normative ways of thinking about art and exhibitions. Perhaps visitors will be inspired to carry this attitude with them as they leave the museum, reassessing their position in society and hopefully realizing that the world is not a fait accompli but a transformable situation. In this spirit, the exhibition follows Walter Benjamin's main objectives: to inspire political agency, to foster social awareness, and to advance critical thinking.

Galerie Vivienne, Paris, 1906, built 1823,
photographed by Eugène Atget

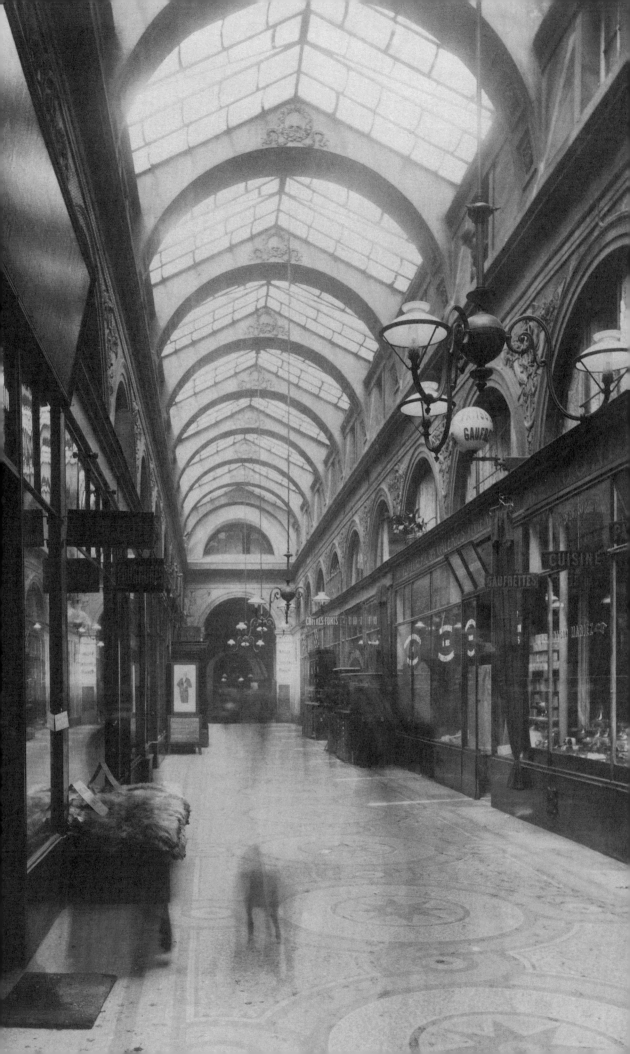

Benjamin's Arcades

The arcades (in French *passages*, in German *Passagen*) were a type of urban space invented in nineteenth-century Paris: covered pedestrian passages or corridors that typically ran through a city block between two streets. Roofed with glass and cast iron and filled with shops, restaurants, cafés, hairdressers, and other businesses, they protected shoppers from the elements and the ordinary (dirty) life of the city.

Arcades are the precursor of the ubiquitous shopping malls of the twentieth century, and Walter Benjamin spoke of them as the most significant architecture of the nineteenth century. He understood them as a social, historical, and cultural phenomenon—as poignant manifestations of capitalism's simultaneous promise of liberation and oppression through consumerism. For him they were temples of commodity, linked to the expanding market economy and created for profit rather than utility. Their seductive displays led an irrational worship of objects; indeed, they were a blatant example of exchange value over use value. That we continue to think about the arcades today as manifestations of early consumer society is in no small part thanks to Benjamin.

Nineteenth-century Paris had more than forty arcades; in *The Arcades Project* Benjamin mentions many of them, and the twenty-one he focuses on the most are listed opposite. They were a constant reference point in his other works as well, notably in the development of his concept of the flâneur, the casual urban stroller who turned window shopping and observing into an art form. Although most of the arcades have been destroyed, several survive.

1786 Galeries de Bois, Palais-Royal, 1st Arrondissement, (considered the first built, 1786 renamed Galerie d'Orléans, 1828)

1794–95 Passage des Colonnes, Rue des Filles-Saint-Thomas–Rue Feydeau, 2nd Arrondissement (demolished 1910)

1798–99 Passage du Caire, 2 Place du Caire, 2nd Arrondissement (first arcade vaulted with glass; has three wings and six entrances)

1800 Passage des Panoramas, 10 Rue Saint-Marc–11 Boulevard Montmartre, 2nd Arrondissement (first public space in Paris lit by gas)

1820 Passage des Deux-Pavillons, 6 Rue de Beaujolais–5 Rue des Petits-Champs, 1st Arrondissement

1822 Passage de l'Opéra, Boulevard des Italiens, 9th Arrondissement (demolished 1925)

1823 Passage Colbert, 4 Rue Vivienne, 2nd Arrondissement

1823 Passage du Pont-Neuf, 44 Rue Mazarine–45 Rue de Seine, 6th Arrondissement (demolished 1912)

1823 Galerie Vivienne, 4 Rue des Petits-Champs–6 Rue Vivienne, 2nd Arrondissement

1824 Passage du Cheval-Blanc, 2 Rue de la Roquette–21 Rue du Faubourg Saint-Antoine, 11th Arrondissement (later restructured)

1825 Passage du Grand-Cerf, 145 Rue Saint-Denis–10 Rue Dussoubs, 2nd Arrondissement (highest vaulted arcade)

1825 Passage Saucède, Rue Saint-Denis–Rue Bourg l'Abbé, 2nd Arrondissement (demolished 1852)

1826 Galerie Véro-Dodat, 19 Rue Jean-Jacques Rousseau–2 Rue du Bouloi, 1st Arrondissement

1827 Passage Choiseul, 44 Rue des Petits-Champs–23 Rue Saint-Augustin, 2nd Arrondissement

1828 Passage Brady, 43 Rue du Faubourg Saint-Martin–46 Rue du Faubourg Saint-Denis, 10th Arrondissement

1828 Passage des Gravilliers, 10 Rue Chapon–19 Rue des Gravilliers, 3rd Arrondissement

1830 Passage du Prado, 18 Boulevard Saint-Denis–Rue Faubourg Saint-Denis, 10th Arrondissement

1830 Passage du Saumon, 80 Rue Montmartre–8 Rue Mandar, 2nd Arrondissement (demolished 1899, partly preserved as Passage Ben-Aïad)

1860 Passage des Prince, 5 Boulevard des Italiens–17 Rue de Richelieu, 2nd Arrondissement (demolished 1885, rebuilt 1995)

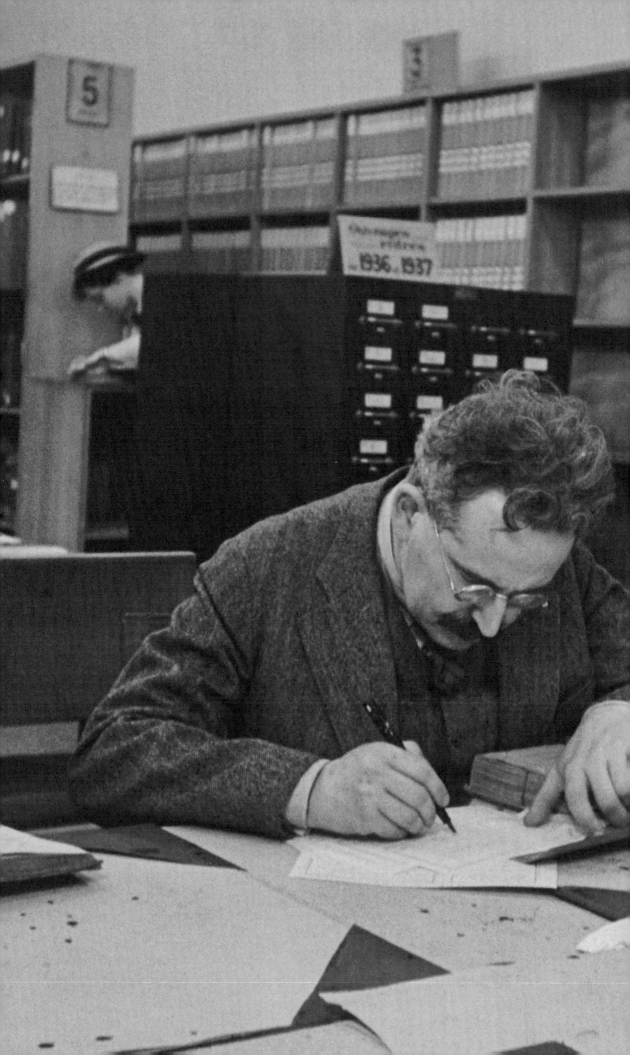

Walter Benjamin in the Bibliothèque
Nationale, Paris, 1937, photographed
by Gisèle Freund

The Optical Unconscious in the Age of Its Technical Reproducibility
Caroline A. Jones

> For now, I only want to report that the San Remo weeks
> are entirely reserved for the study of C. G. Jung. It is my
> desire to safeguard certain foundations of "Paris Arcades"
> methodologically by waging an onslaught on the doctrines
> of Jung, especially those concerning archaic images and the
> collective unconscious.
>
> Walter Benjamin, July 1937[1]

Convoluted

Once upon a time, id roved the land. There was a popular political figure who
didn't have to win elections to gather press attention. His policies were often
vague, but in the media of the time they seemed seductively powerful, stroking
and stoking mass anxieties about immigrants, non-Christian religious affilia-
tions, and economic instability. There were violent outbreaks at his rallies, but
those in power thought they could handle the demagogue. Relations to consti-
tutionality were so convoluted, it seemed the people would just as soon forget
about all that, mesmerized by the leader's hyperbolic masculine anger. All ambi-
guities and doubts were incinerated in a warm glow of incandescent ignorance.
Unlike our current moment in the United States, however, the
Germany of the late 1920s and 1930s had Walter Benjamin. And while the

24

I am grateful to the work of two schol-
ars of Weimar Germany, Nimrod
Reitman and Rebecca Uchill, and to
their informative readings of this es-
say in draft. 1. Benjamin to Gershom
Scholem, July 2, 1937, in *The Corre-
spondence of Walter Benjamin and Ger-
shom Scholem, 1932–1940* (New York:
Schocken Books, 1989), 197. 2. The
longing for the unfinished manuscripts
Benjamin carried with him when he fled
from the Fascists is profound, amplified
by tragedy and loss. Benjamin took
one—or was it two?—suitcases full of
handwritten works, unique writings
lost after his tragic suicide at the border.

His one book, intended as the *Habilita-
tionsschrift* to complete his certification
for a university career, was completed
in 1925 as *Ursprung des deutschen
Trauerspiels*, published in 1928. (The
earlier PhD thesis on art criticism is
rarely counted as a complete book.)
This study of minor tragic dramas from
the German Baroque, focusing on evi-
dence for "sovereign violence," seems
rather prophetic now, but at the time
it was deemed impenetrable. Benjamin
withdrew it from consideration after
its rejection by the academy, and as a
result he was never certified for a uni-
versity appointment. He struggled with

precarity throughout his career. 3. In
his "Theses on the Philosophy of His-
tory" (also known as "On the Concept
of History"), Benjamin comments spe-
cifically that in "voicing" the past, the
historian risks having herself, and the
history she narrates, become completely
forgotten: "The good tidings which the
historian of the past brings with throb-
bing heart may be lost in a void the very
moment he opens his mouth." Luckily,
in Benjamin's case this voicing has be-
come an ongoing murmuration that fills
the void with Benjaminian aphorisms.
Quotation from section V in Walter
Benjamin, *Illuminations: Essays and*

Fascist state and its military allies would ultimately destroy him, murder his brother, force the loss of his manuscripts, and disperse his intellectual cohort, they failed to burn or ban any Benjamin books—because only one existed, and Benjamin himself had withdrawn it from serious consideration.[2] Walter Benjamin's oeuvre remains an unfinished, ongoing project, which has allowed his writing to be carried on, like the internally memorized and socially shared texts spoken in the murmuring forest of *Fahrenheit 451*, full of nuances and aperçus that are hardly realized until they are voiced, handled with the tongue and breath, passed on to a waiting ear, used as an epigraph (as here), or textually cut, chunked, rearticulated, and reassembled.[3] Benjamin is a tool as well as a corpse/corpus, and we are still honing its edge.

This essay touches on one of the hundreds of concepts Benjamin gave us, in an attempt to sharpen its utility: the "optical unconscious." Like so many of his ideas, this one was forged in a desperate effort to find a collective polity that could oppose other mass formations that were rising at the time (the "aestheticized politics" of Nazi ritual, the "collective unconscious" of Carl Jung).[4] In that same spirit, I seek to parse the politics of Benjamin's deeply held concept to update it for our present: the optical unconscious can be brought to light from the dark interior of our collectives; it will be revealed through the sudden shearing of an image, or through a sidelong thought, or via an unwitting parapraxis; we will have scintillating glimpses triggered and enabled by new media, offering new potential for collective understanding and action, in the ongoing project of fixing the world.[5]

"Fixing" is a leftist dream, and a photographic technique for capturing an image. It is also a progressive verb (a gerund), open-ended and thus appropriate to Benjamin's *Arcades Project*. There was madness to Benjamin's method, but it was along the organized spectrum of our necessary derangements—fixing through the dialectic, fixing in memory, fixing as an ongoing process of engagement. His was an ambivalence that counted as an antidote to the techno-positivism of his age. No Luddite, he cultivated a relationship to new media (in his time, film and photography) that fused with his socialism to propel the diagnostic tools seducing us still. Who has not found gnomic omens in the famous "Work of Art" essay? Who among Benjamin's readers has not wandered in his *Arcades*, besotted with their critical potential, but also drifting in their dazed sublimity? The injunction to parse the aestheticization of politics (while politicizing aesthetics) has never been more urgent. The issue is *how to proliferate* Benjamin's mad method. Does art have the right tools? The right reach? This essay will polemicize that it could, and that returning to Benjamin's "arcadean" concept of the optical unconscious will remind us how.

Reflections, trans. Harry Zohn (New York: Schocken Books, 1968), 255. 4. Benjamin warned about the Nazis' aestheticization of politics at the conclusion of the famous "Work of Art" essay ("Das Kunstwerk im Zeitalter seiner technischen Reproduzierbarkeit," written in 1935 and published in 1936), which my essay's title intentionally echoes. Better translated as "The Work of Art in the Age of Its Technological Reproducibility," its most familiar English variant is "The Work of Art in the Age of Mechanical Reproduction," trans. Harry Zohn for the posthumous *Illuminations* (New York: Harcourt

Brace Jovanovich, 1968), 217–51. There is a postwar German legacy to these efforts as well, for which see Friedrich Kittler, *Optical Media*, trans. Anthony Enns (Cambridge, UK: Polity Press, 2010). See this section from page 30, beginning with Kittler's quotation from Freud, *Civilization and Its Discontents*, in which with media supplementation so-called modern "man has, as it were, become a kind of a prosthetic god. When he puts on all his auxiliary organs he is truly magnificent," yet he is abject without them because "those organs have not grown on to him" (Freud,

1953–74, XXI, pp. 91–92). Nothing against this mixture of power and powerlessness, the sublimity and the absurdity of people according to Freud and McLuhan; but their unquestioned assumption that the subject of all media is naturally the human is methodologically tricky. For when the development of a medial subsystem is analyzed in all of its historical breadth, as the history of optical media is being analyzed here, the exact opposite suspicion arises that technical innovations [progress] completely independent of individual or even

Imprinted

We are still working our way out of a modernism Benjamin could not have known—some variants exhibited at this museum, where "primary objects" gave way to "software" in the 1970s, systems critiquing form with notions of process that read a politics out of techno-utopian art.[6] The problematization of modernism in the long postwar epoch turned on new readings of Benjamin, quaffing the scent of his political urgency but largely evacuating his Marxist politics.[7] As in Theodor W. Adorno's excision of "Communism" from the first published version of the "Work of Art" essay, later readers of Benjamin were uncomfortable with his explicit socialism, even though the concept of the optical unconscious was crafted in a careful turn to Sigmund Freud, while pivoting from Soviet models of collectivization.[8] Notably, the critical postmodernism of Rosalind Krauss—as in her 1993 book *The Optical Unconscious*—alluded "at an angle" to Benjamin's concept even as it pursued deeply psychoanalytic framings that seemingly ignored the political, urban dimensions of the early twentieth-century artistic practices she discussed.[9]

How *should* the optical unconscious be theorized?

Benjamin himself offered only tantalizing clues. First mentioned in 1931 as the "thoroughly historical variables" revealed by new media (for instance photography and film in the hands of montage artists), the "optical unconscious" implied two things: it was capable of utilizing the apparatus of art and science (for example, optics), and it could be plumbed through analysis by a trained observer (as an unconscious that would inevitably leach into conscious awareness, where it could be "decoded" by those prepared to see it). Indebted equally to Freudian psychoanalysis and to Karl Marx's rhetoric of the camera obscura and phantasmagoria, Benjamin accepted socialism's critique that technology, particularly in the hands of commodity capitalism, could lull us into an uncritical stupor. Yet he insisted that with the help of psychoanalysis it could also be the agent of our sudden enlightenment, allowing us to peer into the id and control the unconscious drives lurking therein. As the media theorist Tom Gunning observes, Benjamin retooled Marx: he "dialectically develops this tradition by understanding optical devices . . . as not simply deceiving or creating illusion but as articulating the . . . relation between the private dreaming self and the public space of production and history."[10] And he also altered Freud: "The unconscious that operates in Benjamin's arcades . . . opens itself up to the invasion of social history."[11] The kinds of insights Benjamin expected from the optical unconscious penetrated everyday vision, but could hardly be seen except through the intervention of media, in their combination with the shock of modernity. Insights could be

collective bodies of people [in] an overwhelming impact on senses and organs in general.
Kittler sees no prospect of a "collective" optical unconscious, as it would require the separation of a mediatic subject from some primordial core. Although initially promising in its dual critique of Freud and Marshall McLuhan ("the Catholic," as Kittler persists in calling him), Kittler's *Optical Media*, in the end, doesn't further an understanding of Benjamin's optical unconscious. Likewise, Kittler's important *Gramophone, Film, Typewriter* (Stanford, CA: Stanford University Press, 1999) takes up aspects of Hans

Magnus Enzensberger's more Benjaminian media theory but then strips out its socialist "political overtones" (per translators Geoffrey Winthrop-Young and Michael Wutz, p. xv). 5. Benjamin's long correspondence with Gershom Scholem is filled with allusions (if not explicit references) to the Talmudic concept of *tikkun olam*—the duty of every Jew to "fix the world." 6. I'm thinking here of a figure such as the artist and curator Jack Burnham, whose grasp of system aesthetics was intended as a full-bore critique of formalism, along the lines of the much better known theorist and artist Robert Smithson. Burnham's *Software*

exhibition for the Jewish Museum, New York, opened in 1970. 7. This argument is worked out in "Postmodernism's Greenberg," chapter 8 in Caroline A. Jones, *Eyesight Alone: Clement Greenberg's Modernism and the Bureaucratization of the Senses* (Chicago: University of Chicago Press, 2015). 8. It should be said in Adorno's defense that he had a problem with Benjamin's *understanding* of Communism, not with Communism per se. Nonetheless, the fateful excision of this term from the "Work of Art" essay gave that piece of writing a potential for formalist interpretation, which the inclusion of Communism would

glimpsed, as he said, in photography's "material physiognomic aspects [and] image worlds," which functioned like visual parapraxes in a collective psycho-analytic exchange.[12]

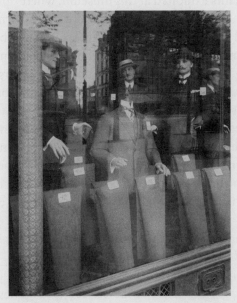

Eugène Atget,
Avenue des Gobelins,
Paris, 1925.
Albumen silver print
from glass negative,
8⅝ × 6⅞ in.
(21.9 × 17.3 cm)
Metropolitan Museum
of Art, New York,
Ford Motor Company
Collection, Gift of Ford
Motor Company and
John C. Waddell, 1987

How might this operate? Again Benjamin offers no specific case studies, but let's do it ourselves, using for our example a photographer he deeply admired. Eugène Atget's 1925 photograph *Avenue des Gobelins* is ripe for collective revelation. The camera stupidly records the reflections on the surface of the glass, as well as in the infinity chamber of the projecting bay window in a Parisian men's clothing shop. Rather than "looking through" the glass as we would in life, peering at the textures and colors of the English tweeds in order to fantasize about our enhanced existence if we could afford them, the photograph

Focal center of
Avenue des Gobelins

27

certainly have made more difficult. For an updated translation of Benjamin's crucial essay, which restores certain excised passages, see "The Work of Art in the Age of Its Technical Reproducibility (Second Version)," trans. Edmund Jephcott and Harry Zohn, in Walter Benjamin, *The Work of Art in the Age of Its Technical Reproducibility and Other Writings on Media*, ed. Michael W. Jennings, Brigid Doherty, and Thomas Y. Levin (Cambridge, MA: Belknap Press of Harvard University Press, 2008), 19–55. 9. Rosalind E. Krauss, *The Optical Unconscious* (Cambridge, MA: MIT Press, 1993), 179. As I argue here, since

humans constructed the concept of the unconscious to explain the internally experienced passage from drives to actions, there is no reason we can't enlarge it, à la Benjamin, to function in a collective social frame. Krauss's claim that such a move "would simply be incomprehensible" rests on a believer's confidence in the modern bourgeois individual, in the Freudian structure of mind, and in artists' *intentions* as more important than a given public's *reception*: "If it [the optical unconscious] can be spoken of at all as externalized within the visual field, this is because a group of disparate artists have so constructed it there . . . as a

projection of the way that human vision can be thought to be less than a master of all it surveys, in conflict as it is with what is internal to the organism that houses it" (179–80). If Krauss appropriates Benjamin to promote certain artists, I attempt to return Benjamin's concept to its original use value, for contemporary artists *but also for their publics*. 10. Tom Gunning, "The Exterior as *Intérieur*," in *Benjamin Now: Critical Encounters with The Arcades Project*, ed. Kevin McLaughlin and Philip Rosen, special issue of *Boundary* 2 30, no. 1 (Spring 2003): 112. For Benjamin's "thoroughly historical variable," see note 12, below.

surfaces a virtual montage. Atget's viewfinder incorporates an overcast sky into the glass reflections, using it to slice through one mannequin head and wash the straw hat off another. The price tags seem to escape this derangement. They hover between inside and out like specters, refusing to allow the commodity a direct address, but instead distilling the calculations of capital (labor, materials, profit) into an insistent scrim of exchange values floating over the dapper display. Finally, those who look at this eminently reproducible image find one element forcing itself into consciousness: the central focal point of the entire composition is a torso whose head is replaced by an uncanny finial—a cranium reduced to a brain stem given two rudimentary eyes, like a sculptural parody of the id diagram (*das Es!*) Freud had first sketched out only two years before. The haunting visuality of Atget's image, its bafflements and interruptions, come into focus here (the detail of the finial/brain stem shows its sharpened clarity), emerging like a sudden parapraxis—one punctum of the optical unconscious, collectivizing us in an eruptive awareness of the commodity's seductions, those "phantasmagorical forms" we are then better equipped to resist.[13]

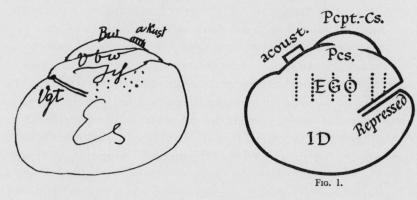

Fig. 1.

Left: Sigmund Freud's sketch of the ego–id relation, drafted in 1923 and published shortly thereafter.
Right: Freud's ego–id diagram, as published in Freud, *The Ego and the Id*, 1923, SE XIX: 24.

Photography was necessary for this potentially political montage aesthetic to come into being. Nothing in pictorial art had prepared us for the layers of glassy reality contradicting each other in Atget's photograph, just as no masonry forms had anticipated the great vitreous panels comprising the Crystal Palace at the 1851 Great Exhibition. Plate glass and its friend the camera lens were crucial to the "commodity universe" and the shopping arcades that instigated some of Benjamin's most trenchant critiques.[14] In this age of mechano-chemical reproducibility, film would partner with glass in a crucial technoscientific burst, extending photography's reach into cinema, with space,

28

11. Ibid., 126. 12. Of course, the "everyday" and its relation to experience (both *Erlebnis* and *Erfahrung*) is extremely rich in Benjamin (see his 1913 essay "Experience"). As one probing, see Martin Jay, "Experience without a Subject: Walter Benjamin and the Novel," special issue on "Actuality of Walter Benjamin," *New Formations* 20 (Summer 1993), available online at http://poieinkaiprattein.org/philosophy/martin-jay/experience-without-a-subject-walter-benjamin-and-the-novel-by-martin-jay. The "optical unconscious" is revealed by photography in Benjamin, but preexists it,

just as Benjamin would hold that the psychic unconscious precedes Freud's discovery of it through psychoanalysis. Walter Benjamin, "A Little History of Photography," first published as "Kleine Geschichte der Photographie," *Die Literarische Welt*, September 18, 25, and October 2, 1931, reprinted in Benjamin, *Selected Writings*, Vol. 2, 1927–1934, trans. Rodney Livingstone et al., ed. Michael W. Jennings, Howard Eiland, and Gary Smith (Cambridge, MA: Belknap Press, 1999), 507–30. The reference to the optical unconscious is on pages 511–12:

Photography, with its devices of slow motion and enlargement,

reveals the secret. It is through photography that we first discover the existence of this optical unconscious, just as we discover the instinctual unconscious through psychoanalysis. Details of structure, cellular tissue, with which technology and medicine are normally concerned—all this is, in its origins, more native to the camera than the atmospheric landscape or the soulful portrait. Yet at the same time, photography reveals in this material physiognomic aspects, image worlds, which dwell in the smallest things—meaningful yet

time, and architecture collectivizing viewers through "mass ornament" in movie palaces just as Busby Berkeley and the Tiller Girls collectivized dancing bodies into ornamental assemblies for the new reproductive media, massed females figuring capitalism's newest body ego.[15]

Benjamin's enthusiasm about how photography and film were structuring new kinds of subjects resonated with the emotions felt by other leftist artists and theorists in Weimar Germany, among them Siegfried Kracauer, Rudolf Arnheim, and the Berlin cohort that founded the new journal *G: Material zur elementaren Gestaltung* (G: Materials for Elemental Form Creation, 1923–26), a group that included László Moholy-Nagy and the Dadaist Hans Richter.[16] New media, rather than merely serving the technocratic "picturing" of the world in the optic Martin Heidegger would soon abjure in his 1938 "World Picture" essay, was positioned by these theorists instead as a critical force that could be mobilized in the practices of transformative artists and their activated publics.[17] Anticipating the emergence of this collectivized public sphere, Benjamin theorized its optical unconscious as constituting a "dialectical, Copernican turn of recollection" that could expose the "dreaming collective" otherwise left floating without that revolutionary reorientation, adrift in the phantasmagoria of the great exhibitions and their commodity universe.[18]

Photography and film were ripe for registering a *collective* unconscious precisely because of their capacity to record an image automatically, with all of the Proustian metaphors attending that magical operation, yielding results that could then be mechanically reproduced and widely distributed for all to see. But the automaticity of the image did not obviate later interpretation and intervention. This is the working of the art. The dialectical materialist, in fact, was like the photographic artist from the beginning. The photographer or filmmaker might fiddle with aperture and exposure but "in the end . . . releases the shutter and presses." When the magic inscription is complete, the work of analysis can ensue (first through the surgeon/artist's cut, then through the psychoanalytic/dialectic):

> Once he has removed the plate—the image of the thing as it entered the social tradition—the concept takes its rightful place and he develops it. For the plate can only offer a negative. It comes from an apparatus which substitutes shadow for light and light for shadow.[19]

Benjamin's enlightenment metaphors are well considered, and their dialectical import is clear: the photographic negative is the inverse of the developed positive of materialist consciousness. (This is a knowing expansion

29

covert enough to find a hiding place in waking dreams, but which, enlarged and capable of formulation, make the difference between technology and magic visible as *a thoroughly historical variable* [end quote, emphasis added].
I want to insist on the role of technology in revealing this social and political reality—and on the potentially critical nature of that revelation. Recall that in later essays such as the 1936 "Work of Art" piece, Benjamin repeats, "The camera introduces us to unconscious optics as does psychoanalysis to unconscious impulses." Benjamin, *Illuminations: Essays*

and Reflections, 237. It is the shared, collective, and political aspects of this "visceral modernity" that later theorists, including Rosalind Krauss, unaccountably minimize in their adoption of Benjamin's term. Krauss theorized anti-ocularity and the pulsative "unconscious" of modernism as directly referencing the classic Freudian traumas of castration, made relevant for postmodernism through Melanie Klein's part-objects and Lacanian readings of linguistic difference. I don't disagree with this reading, but want to find connections between private subjects and public politics that rely on more than a posited

psychic universalism. For more on these potentials, see the recent monograph by Michael Jennings with Howard Eiland, *Walter Benjamin: A Critical Life* (Cambridge, MA: Harvard University Press, 2014). 13. Note that Benjamin takes his concept of the "phantasmagoria" directly from Marx, from whom he cites this passage in the *Arcades*: "This fetishism of commodities has its origin . . . in the peculiar social character of the labor that produces them. . . . It is only a definite social relation between men that assumes, in their eyes, the phantasmagorical form of a relation between things." Karl Marx, *Capital*, vol. 1 (New York:

of Freud's well-known observation that there are no negatives in the unconscious.) Antithesis to the intellectual's thesis, the photographic negative is preparatory to a collectivized synthesis—this is the dialectical method. We recognize this in Benjamin's desire as a historian to embed a figure such as Charles Baudelaire in his own historical epoch—formed, but also forming, his century. Analogized by Benjamin to a stone "that has been lodged in the soil of a forest for decades," such a critical imprint is only revealed in history, when the buried rock has been "laboriously rolled away" and the shape of its impact is revealed "with pristine clarity"—another type of negative requiring dialectical interpretation.[20] Such processes of revelation and interpretation are analogous to suddenly revealed aspects of our "collective interior, concealed within an individualist psychology" (as Tom Gunning puts it) but unearthed by the work of patient analysis.[21]

We have to dig it out.

Like the Surrealist uncanny, our collective interior is revealed by means of excavation. A suddenly exteriorized interior space, it is wrested from the isolation of the individual and propelled, through new media, into a consciousness we can share. The *unheimlich* exteriorization of the id (the crisp hole that used to be under the stone, now seen to be crawling with life and hidden agency) becomes the new, critically framed interior of the collective. Via the shared image, it can be introjected by all. Transferring and enlarging Freud's methods to the social, Benjamin crafts a radically new and entirely political operation. As part of this exterior/interior reversal (the spatialized dialectic he analogizes to the flat photographic negative), what was utterly exterior as "social noise" is folded into the new collective's interior, with the operation reversed again via the dialectics of interpretation.[22] He demands that we see how

> much that is external to the former [the individual] is internal to the latter [the collective]: architecture, fashion—yes even the weather—are, in the interior of the collective, what the sensoria of organs, the feeling of sickness or health, are inside the individual. And so long as they preserve this unconscious, amorphous dream configuration, they are as much natural processes as digestion, breathing, and the like. They stand in the cycle of the eternally selfsame, until the collective seizes upon them in politics and history emerges.[23]

30 The "concrete states of consciousness," in Benjamin's Freudian understanding, function regardless of being "patterned and checkered by sleep

Modern Library Edition, 1906), 83. See Margaret Cohen, "Walter Benjamin's Phantasmagoria," *New German Critique*, no. 48 (Autumn 1989): 87–107. 14. Benjamin: "World exhibitions glorify the exchange value of the commodity. They create a framework in which its use value recedes into the background. They open a phantasmagoria which a person enters in order to be distracted." Benjamin, *The Arcades Project*, trans. Howard Eiland and Kevin McLaughlin (Cambridge, MA: Belknap Press of Harvard University Press, 1999), 7. And yet distraction-by-visuality is also praised, particularly in the structures by Sir Joseph

Paxton such as the so-called Crystal Palace (see F 4,1 and F 4,2: "Iron Construction" Convolute, 1999, p. 158). Henry Bessemer's perfection of "float" or plate glass in 1848 would make possible the glittering uniformity of Paxton's 1851 Crystal Palace, which used this new form of glass, which was being made in Birmingham by Chance Brothers, newly freed from a British "glass tax." Here, too, it is possible to distinguish my reading from that of Krauss, who sees plate glass in Duchamp's *Large Glass* as constructing itself around opacity: "vision itself within the opacity of the organs and the invisibility of the unconscious."

Krauss, *The Optical Unconscious*, 125. 15. Siegfried Kracauer, *The Mass Ornament: Weimar Essays*, trans. and ed. Thomas Y. Levin (Cambridge, MA: Harvard University Press, 1995), 74–86. In the title essay, Kracauer summarizes his argument: "The hands in the factory correspond to the legs of the Tiller Girls" (79). See a more extensive argument along these lines in Caroline A. Jones, "The Sex of the Machine," in Caroline A. Jones and Peter L. Galison, eds., *Picturing Science, Producing Art* (New York: Routledge, 1998), 145–80. 16. *G* is now available in a superb facsimile/ translation, for which see Detlef Mertins

and waking." That is, the boundary between ego and id does not change in sleep, although sleeping allows the unconscious to emerge in dreamwork. Similarly, the dialectician is challenged to find such patterns in social behavior, within what we call our "experience" (poised exquisitely in German between *Erlebnis* and *Erfahrung*), to understand how experiences are shaped by what preexists them (the political situation, aesthetic formulas, the unconscious) and what kinds of subjects they produce.[24] As he wrote in the Convolute on dreams, "The situation of consciousness . . . need only be transferred from the individual to the collective."[25]

And the task of the intellectual correspondingly moves from the interior of the bourgeois individual subject to the aggregated subjects of mass culture. For Benjamin, the arcades of the shopkeepers become the "perceptual consciousness" (as Freud called the surface of the ego; "Pcpt.-Cs." in the diagram he published in 1923), the sensing units of a vast cultural body. Their glazed, transparent windows become sensible membranes: eyeballs and eardrums that register the signals of capital and render them to us for decoding, for interpretation, for action.

Fredric Jameson channeled this version of Benjamin in his book *The Political Unconscious* (1981). Politicized publics can be produced even from works of culture that are consumed, as Benjamin understood, in "distracted" modes.[26] The move from distraction to collective insight requires the dialectician, and/or the artist (as detective, as psychoanalyst, as optician). Crucially, as the Benjamin scholar Miriam Hansen insists, our analysis of the optical unconscious must precisely "get at the layer of dreams that both sustained and exceeded the historical order of production."[27] These are not the dreams of individuals, but of the mass, the "dreaming collective."[28]

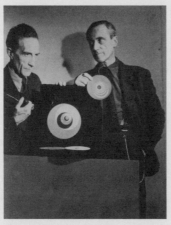

Marcel Duchamp and Hans Richter with Duchamp's *Rotoreliefs* on the set of Richter's film *Dreams That Money Can Buy*, New York, c. 1947. Gelatin silver print, 10 7/8 x 8 in. (25.8 x 20.3 cm), Philadelphia Museum of Art

31

and Michael W. Jennings, eds., *G: An Avant-Garde Journal of Art, Architecture, Design, and Film, 1923–1926* (Santa Monica, CA: Getty Research Institute, 2010). On the importance of the new mediatic subject that G envisioned, see Rebecca Uchill, "Mediating," in Caroline A. Jones, David Mather, and Rebecca Uchill, eds., *Experience: Culture, Cognition, and the Common Sense* (Cambridge, MA: MIT Press, 2016), 35–55. 17. For an argument about Heidegger's essay as a response to the same international philosophy congress that Benjamin attended at the 1937 World's Fair in Paris, see chapter 6 in Caroline A.

Jones, *The Global Work of Art* (Chicago: University of Chicago Press, 2016). 18. Benjamin, in the pre-1935 sections of the unfinished *Passagenwerk*, as cited in the magisterial essay by Miriam Hansen, "Benjamin, Cinema and Experience: 'The Blue Flower in the Land of Technology,'" *New German Critique* 40 (Winter 1987): 179–224, these quotes from p. 191. For Benjamin on the "phantasmagoria" of the universal exhibitions, see *The Arcades Project*, 7. On the "dreaming collective," see note 28, below. 19. Walter Benjamin, *Gesammelte Schriften*, vol. 1, 1165, as translated and cited by Graeme Gilloch in *Walter*

Benjamin: Critical Constellations (Cambridge, UK: Polity Press, 2002), 203. 20. Benjamin in a letter of April 14, 1938, to Gershom Scholem, in *The Correspondence of Walter Benjamin*, ed. Theodor Adorno and Gershom Scholem, trans. Manfred Jacobson and Evelyn Jacobson (Chicago and London: University of Chicago Press, 1994), 554. 21. Gunning, "The Exterior as *Intérieur*," 128. 22. In explicating this folding operation from image to subjectivation, I am indelibly marked by Gilles Deleuze and the concept of the visibility articulated in *The Fold: Leibniz and the Baroque*, trans. Tom Conley (Minneapolis: University

Contingencies

While Benjamin was writing the Convolutes at the Paris Bibliothèque Nationale in 1935, the artist Marcel Duchamp was at an inventors' fair across town, hoping to promulgate his "precision optics" on an unwitting public. These optics took the form of what he called *Rotoreliefs*—antidotes to the commodity universe of "retinal" art and conventional fair goods. Sadly, they failed to form a collective there in Paris, anti-visual or otherwise; they didn't even find buyers at the fair. A few art collectors eventually bought them, giving them to art museums as "high," not mass, culture. Perhaps, like the hypnosis wheels on which they were modeled, the *Rotoreliefs* were not able to multiply the individual viewer, aimed as they were at a single person standing in front of them "just so." But Duchamp complicated things by *filming* the demispheres and flat rotary discs—collectivizing these mediatic probes into the optical unconscious by documenting them in a different, photographically based, mass-media format, whether his own 1926 *Anemic Cinema*, or in Hans Richter's 1947 experimental film *Dreams That Money Can Buy*.

Are we altered by these films (or the gifs you can now find online, animating each of the *Rotoreliefs*)?[29] Do they convert the serially individuated psychedelic objects into culturally collectivized ones? Intentionally erotic, the discs' undulations form voluptuously convex and then concave apparitions, thrusting out at us or sucking us in.[30] In the rare art museum activation, their mechanically pulsating patterns continue to demonstrate that the electromagnetic sense of sight, so convinced of its mastery of the universe, can be undone by the viscera claiming its own response.[31] The "sensoria of organs" that Benjamin theorized as potentially registering the "interior of the collective" is concertized here as a sexy theater of optical vertigo, just strange enough to propel us out of our inertia by modeling "the uncanny intoxication" that "is not the logical contradiction of awakening but its basis."[32] Remember that Surrealism was as powerful an influence on Benjamin as Freudianism or Marxism (it was Georges Bataille who rescued the *Passagenwerk*). In their own time no one knew what to do with either Benjamin's theory of the optical unconscious *or* the *Rotoreliefs'* remapping of the senses. As prescient and fragmentary as a Convolute, Duchamp's objects now seem perfect for triggering theories of embodied cognition and the working of experiential art.[33] They prompt tougher theorizations of what Benjamin might have meant by his collective, pressing the hard question: can aesthetics of the abstract kind (without indexing reality, without the apparatus of text or the instrumentalized affect of propaganda) accomplish a progressive politics of the collective?[34]

of Minnesota Press, 1993). 23. Benjamin, Convolute K (Dream City and Dream House, Dreams of the Future, Anthropological Nihilism, Jung), specifically K1, 5 in Benjamin, *The Arcades Project*, 389–90. 24. *Erlebnis*, "lived experience," was a neologism of the late nineteenth century, departing from the traditional word *Erfahrung*, which suggests "experience through movement in life and thought." Although the former would be polemically connected to a soldier cult by Ernst Jünger following World War I (see his *Der Kampf als inneres Erlebnis* from 1926), Benjamin wrote one of his first essays (from 1913) to connect the two "experience" concepts. Affected by both Nietzsche and the Youth Movement, Benjamin argued that the fresh experiences of youth could be positively contrasted to the dour assertions of age, with their experiences asserted as superior but in fact merely "lived through" (*erlebt*). Note that his Nietzscheanism made it possible for Benjamin to transvalue the older term *Erfahrung* itself, while Jünger and other proto-Fascists would discard it. In contrast to Benjamin, Jünger's valuation of *Erlebnis* privileged it as the warlike embrace of life and risk, over the fussy academicism of metaphysics. For the record, Benjamin's 1913 essay was titled "Erfahrung." See Benjamin, *Selected Writings*, Vol. 1, 1913–1926, ed. Marcus Bullock and Michael W. Jennings (Cambridge, MA: Belknap Press of Harvard University Press, 2004), 3–6. 25. Benjamin, Convolute K, *The Arcades Project*, 389. 26. Fredric Jameson, *The Political Unconscious: Narrative as a Socially Symbolic Act* (Ithaca, NY: Cornell University Press, 1981). While Krauss acknowledges that her title "rhymes" with Jameson's, she remains committed to object relations theory and the Lacanian preoccupation with the linguistic. While I value these theories of individuation, I

Pleasure is the gateway. And this includes the pleasures of intellection and critique. Just as drives of the id must be channeled by the ego for social purposes (they can never be fully blocked or turned off), so can art collectivize our pleasures for modest revolutions of the subject. In place of the politics of fear (and its companion in the death drive), let us imagine a politics of positive desire: in the opening to difference, in tolerance for ambivalence, in the destabilization of the uncanny, in play, in thought. Benjamin theorized the optical unconscious's "blind, senseless, obsessive . . . will to happiness" as negotiating the traumatic "shock" of modernization, with utopian possibilities for collective response as a result.[35] I've speculated on Duchamp's practice in the *Rotoreliefs* (particularly the collectivizing films) as opening onto the potential for an optical unconscious, collectively parsed; Andy Warhol's long takes could provide another example of a suspension of fear and an invitation to meditative idleness. *Sleep*'s (1963) luxuriant lassitude, reflective inaction, and seductive REM cycles (dreamwork seen from without)—these are refusals of everyday death and disasters. The artist Pierre Huyghe riffs and updates this version of Warhol, while also staging/erasing the passage of time, and laying a soundtrack of the sleeper's formerly unheard thoughts (see page 105). In the craggy, drowsing brow, the unfinished work of poetry germinates, while film forms collectives from the isolated id.

It's crucial that technology be involved, but it needn't be fancy. All it has to do is take us from the overlooked knowns of the everyday to that "space informed by the unconscious," that *other* nature that "speaks to the camera" (or the 3D scanner, or the digital editing algorithm) rather than the eye. Then and there we might find it, that tiny something that bursts into the collective:

> the tiny spark of contingency, of the Here and Now,
> with which reality has so to speak *seared the subject*,
> to find the inconspicuous spot where in the immediacy
> of that long-forgotten moment the future subsists so
> eloquently that we, looking back, may rediscover it
> (emphasis added).[36]

The pleasure of a chemically induced sleep, watched by the jittery urban insomniac of Warhol in 1963, stretches via Huyghe to the unlikely future, in which the queer poet John Giorno (he of the 1964 *Pornographic Poem*, he of Warhol's luxuriant 1963 *Sleep*) brings his community through AIDS and founds its Buddhist antidote (the AIDS Treatment Project), roaring defiant into our present of legislated gains and murderous losses.[37]

33

am interested in reviving Jameson's view of the political as "the absolute horizon of all reading and all interpretations" (from the opening paragraph of Jameson's book). 27. Hansen glossing Benjamin in "Benjamin, Cinema, and Experience," 221. 28. The phrase "dreaming collective" is one developed by Benjamin specifically in regard to the arcades, and adopted by Adorno in their correspondence. For an exploration, see Andrew Gelley, *Benjamin's Passages: Dreaming, Awakening* (New York: Fordham University Press, 2014). 29. *Rotorelief* stills are well documented in this blog: http://thebluelantern .blogspot.com/2012/08/the -marvelous-rotoreliefs-of-marcel_25 .html. For examples of *Rotoreliefs* animated as gifs, see http://giphy.com /search/rotoreliefs. Duchamp's short 1926 film *Anémic Cinéma* is posted on Vimeo: https://vimeo.com/4748112. 30. Krauss gets this vividly right, describing the "Chinese Lantern" pattern as mobilizing into "a breast with slightly trembling nipple" and the "Corolla" becoming "an eye staring outward." The rotary reliefs "produce a fairly explicit sexual reading." Krauss, *The Optical Unconscious*, 96. In a rare act of citation, Krauss insists: "Others, other scholars in fact, have concurred." One finds them, with some difficulty, in the bibliographic notes. 31. With its dependence on print and photographic documentation, art history would largely pass over Duchamp's rotary devices. On Duchamp's "carnal" vision, see Jean-François Lyotard, *Les Transformateurs Duchamp* (1977), translated as *Duchamp's TRANS/formers* (Venice, CA: Lapis Press, 1990), frequently cited in Krauss, *The Optical Unconscious*. In specific regard to the *Rotoreliefs* see Scott Richmond's forthcoming book on Duchamp and proprioceptive aesthetics, *Cinema's Bodily Illusions: Flying, Floating, and*

A different "spark of contingency" might flash from the floor of Andreas Gursky's *Chicago Mercantile Exchange* (1997), one glinting off the financial tools that carved out our world of woe and foreclosures, feeding demagoguery's affect of zombie apocalypse (see page 97). The spark continues its burning trail, revealing the desperate, incendiary circumstances that perhaps only the montages of *Black Dada* can interrogate. Adam Pendleton's *Black Dada (D)* (2014) speaks of the future while voicing the past—the kind of loop Benjamin saw propelling the optical unconscious. Some kind of noun,

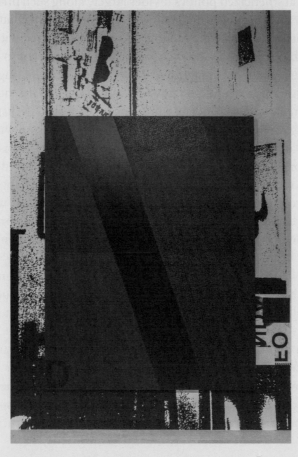

Adam Pendleton, *Black Dada (D)*, 2014. Screenprint on two canvas panels, 48 x 76 in. (121.9 x 193 cm) each. Courtesy of the artist, New York

"Black Dada" also wants a verb's agency, and the id's transformative force: "Black Dada is neither madness, nor wisdom, nor irony, nor naiveté. . . . The Black Dada's manifesto is both form and life. Black Dada your history of art."[38] Black Dada is Benjaminian to the core, our optical unconscious blurting out in Arial fonts and dark gleanings of racial difference, the matter of identities shared and collectivized as matters of concern.[39]

34

Hallucinating (Minneapolis: University of Minnesota Press, 2016). 32. Gunning, "The Exterior as *Intérieur*," 127. 33. For explorations of visceral knowing, see Alva Noë, *Out of Our Heads: Why You Are Not Your Brain, and Other Lessons from the Biology of Consciousness* (New York: Hill and Wang, 2009), as well as Lawrence Schapiro, *Embodied Cognition* (New York: Routledge, 2011). 34. Nearly a century has passed since some of Benjamin's writings, and there have been multiple contributions to this debate between realism and abstraction, whether Ernst Bloch versus György Lukacs, or, more locally, Meyer Schapiro,

Clement Greenberg, and Adorno struggling to position avant-garde abstraction as socially progressive despite its eschewal of "representational content." 35. Benjamin, in the 1932 remarks on Proust, cited by Hansen, "Benjamin, Cinema, and Experience," 202. For "shock," see pp. 184–85 and elsewhere. See also Richard Shiff, "Handling Shocks: On the Representation of Experience in Walter Benjamin's Analogies," *Oxford Art Journal* 15, no. 2 (1992): 88–103. 36. Benjamin, "A Small History of Photography" (1931), in *Walter Benjamin: One-Way Street and Other Writings*, trans. Edmund Jephcott and

Kingsley Shorter (London: New Left Books, 1979), 243. I use multiple English translations of this text (and others) for variety, and to point to variations in translation from Benjamin's original languages of German and French (see note 12 above). 37. I wrote that sentence before hearing the news of a murderous rampage in a gay dance club in Orlando (June 12, 2016). Provocations, and guns, proliferate along with their digital recordings on jihadist websites, white supremacist digital communities, and Facebook gun sellers—all features of the Internet along with rainbow coalitions. "New media" is agnostic as to the

Collectives

Pendleton furthers one part of Benjamin's unfinished opus. By canceling the white supremacist project of Carl Jung's "collective unconscious" (and its present-day Tea Party analogues) through Black Dada operations, he allows viewers to assert the necessity for an entirely different mechanism of collectivization. This is a collective formed through solidarity, rather than a fantasy of racial essentialism (and the contemporary urgency of a politicized aesthetics rather than an aestheticized politics divides largely along such lines).

In his own time, it was Benjamin's fervent objective to find the means to defeat Fascist and racialized structures, both by associating with the shouting graphic artists of *G* and in private commentaries sent to his stalwart correspondents Gershom Scholem and Teddy Adorno. Preparing to attend and report on the 1937 World Congress of Philosophy in Paris, he was nonetheless distracted by the urgency of thwarting C. G. Jung: "Perhaps you have heard that Jung recently leaped to the rescue of the Aryan soul with a therapy reserved for it alone. . . . These auxiliary services to National Socialism have been in the works for some time."[40] Benjamin's *Arcades Project* depended on clarifying the operative difference between Jung's toxic mythological unconscious and his own socialist one. Ironically, each "son of Freud" was pursuing a crucial differentiation from Freud's individualist model: Jung on the basis of racial unities and mythic "spooky actions at a distance," Benjamin on the basis of the dialectical consciousness of the working class.[41] Jung was much more famous, hence the task loomed as incredibly important. Benjamin reported to Scholem a month later: "I have begun to delve into Jung's psychology—the devil's work through and through, which should be attacked with white magic."[42]

Adorno, however, was suspicious of any magic, even the anti-Jungian kind. How "to understand the commodity as dialectical image"? It would require, Adorno scolded, "true objectivity and its correlate, namely, alienated subjectivity." Benjamin's poetic methods were dangerous, and Adorno advised that they just get rid of this optical unconscious altogether:

> It is up to us to polarize and dissolve this "consciousness" dialectically between society and the single subject, and not to galvanize it as the metaphorical correlate of the commodity character. It should be a clear and adequate warning that no differences remain between classes in the dreaming collective.[43]

politics it will facilitate. 38. Adam Pendleton, *Black Dada Manifesto* (2008). Portions online at http://adampendleton.net/wp-content/media/pendleton_beasley.pdf. 39. Bruno Latour, "Why Has Critique Run Out of Steam? From Matters of Fact to Matters of Concern," *Critical Inquiry* 30 (Winter 2004): 225–48. 40. Benjamin to Scholem, July 2, 1937, in *The Correspondence of Walter Benjamin and Gershom Scholem, 1932–1940*, 197. 41. One of the reasons Freud fired Jung from his circle was the latter's failure to distinguish between a science of mind amenable to empirical tests, versus an embrace of occult phenomena such as poltergeists and spirit mediums. The phrase "spooky action at a distance" is Albert Einstein's (*spukhafte Fernwirkung*), reflecting another secular Jew's skepticism about unverifiable actions, in this case between entities entangled in quantum dynamics. 42. Benjamin to Scholem, August 5, 1937, here from *The Correspondence of Walter Benjamin*, 544. Scholem comments later on this intention to expose Jung: "WB also expressed his views on C. G. Jung's psychology in letters to Horkheimer and Adorno (as early as 1934!), but as far as I know he did not leave a substantive critique." Benjamin's rejection of Jung, largely unrealized in print, is usefully parsed in Andrew Benjamin's essay "Time and Task: Benjamin and Heidegger Showing the Present," included in his edited volume with Dimitris Vardoulakis: *Sparks Will Fly: Benjamin and Heidegger* (Albany: State University of New York Press, 2015), 145–76. See also Andrew Benjamin, *Working with Walter Benjamin: Recovering a Political History* (Edinburgh, Scotland: Edinburgh University Press, 2013). 43. Adorno to Benjamin, August 2, 1935, in *The Correspondence of Walter Benjamin*, 497. Note that Adorno adopts Benjamin's term "dreaming collective" without reserve in

The Jungian idea of the collective—prepopulated with Greco-Aryan mythologies and untouched by new media—was never publicly contested by Benjamin, sadly. If Benjamin hoped in 1937 to expose the "Fascist armature" of Jungian psychology, his precarity ensured there would be no commission for such an essay, no one willing to pay for his exposure of the highly success-ful Swiss psychoanalyst. Benjamin retreated to the arcades.[44] Facing an age "in which demons . . . rejoice at being alive," he turned back to the library and embraced the open-ended project of the Convolutes.[45]

Left for us in its germinal form, the optical unconscious remains, to my mind, the greatest gift of Benjamin's arcadean project. His hope that new media could reveal truths concealed from dissembling power elites is a recognizable goal of much contemporary art production. In the Convolute on photography, Benjamin saw how "a new reality unfolds, in the face of which no one can take responsibility for personal decisions."[46] For "personal decisions" read *subjective expression*, preserved by Eugène Delacroix (in Benjamin's account) for the practice of painting, but devalorized early on by photography and by Adorno's and Neue Sachlichkeit artists' account, which emphasized a new objectivity and a neutralized affect. Benjamin understood that the affect was crucial, how-ever; it was art's link to the engine room of the id.[47] If the right (instantiated by Heidegger) saw the threat to collectivity and the social in "mere subjectivism" and the modern "cult of the individual," leftists in Benjamin's circle would not disagree.[48] But the terms they would explore for the collective were radically different from Heidegger's metaphysic.

In turning from the subjective, Benjamin was not aiming for a primitive (Heideggerian) past, but for an actively social future. The optical unconscious could be thought of as a collective, sensate organ, pulsing with interiorized social surfaces and exteriorized drives, ripe for critical reading by those willing to sift through the visual noise. This mode of cultural cognition needs the social labor of shared discourse, based on individual mulling and re-member-ing but aggregated for collective political response. More like John Dewey's pragmatic public than Heidegger's *Volk*, Benjamin's project calls to our better natures. His moment of potentiality stretches into ours, as we claim new media's power for shared political revelation (against demagogic phantasms), and insist on a politics embedded in aesthetics, and worth fighting for. Art can incorporate our exteriors into a new interior for the collective, but the politics we will forge from that operation are up to us.

this letter—he is simply refusing the idea that class would survive revolution and persist in marking the collective uncon-scious Benjamin is envisioning. 44. Ben-jamin to Fritz Lieb, July 9, 1937, in *The Correspondence of Walter Benjamin*, 542. 45. Ibid.: "I ask myself whether there might not perhaps be a kind of his-torical, semiannual period in which de-mons, instead of those who are simply not free, rejoice at being alive and wheth-er we might not have entered upon such a period. I can imagine that, on account of the conditions of our existence, we will appear distorted to later genera-tions, as if we were dragging around with us a welter of abortions in the form of demonic parasites." 46. Benjamin, Convolute Y, "Photography," Y5, 3, *The Arcades Project*, 678. 47. Sigmund Freud, "The Ego and the Id," 1923, SE 19, p. 26: "The ego is first and foremost a bodily ego; it is not merely a surface entity, but is itself the projection of a surface [the projection of the surface of the body]." Further: "The ego represents what may be called reason and common sense, in contrast to the id, which contains the passion." The medieval concept of "the passions" would, in Silvan Tomkins's "affect theory" of the 1960s, become "the affects," thought to be more primitive and basic than the cognitively controlled "emotions." Tomkins distin-guished the affects from Freudian drives because they have no objects. 48. These characterizations are Adorno's, reading Hegel to counteract Heidegger. See The-odor Adorno, "Aspects of Hegel's Phi-losophy," in Adorno, *Hegel: Three Studies* (Cambridge, MA: MIT Press, 1993), xxiii. Also see Adorno, *The Jar-gon of Authenticity* (from the 1964 Ger-man, *Jargon der Eigentlichkeit: Zur deutschen Ideologie*), trans. Knut Tar-nowski and Frederic Will (Evanston, IL: Northwestern University Press, 1973).

Convolutes
Annotations by Kenneth Goldsmith

The Convolutes, page from Benjamin's notes for *The Arcades Project*, date unknown, between 1928 and 1940
Walter Benjamin Archiv, Akademie der Künste, Berlin

A Arcades, *Magasins de nouveautés,* Sales Clerks

AN EVOLVED VERSION OF THE STREET.[1]

When these abstracted forms, viewed in isolation and not as elements within the fabric of the city, become the model by which to envision an urban realm, the result is an utter depletion of possibility.[2]

Control space evaluates space through an entirely modernized vocabulary: no longer it is geometrically composed or visualized, but computed, calibrated, assessed, predicted, optimized.[3]

A fuzzy empire of blur, it fuses high and low, public and private, straight and bent, bloated and starved to offer a seamless patchwork of the permanently disjointed.[4]

They

sit

unto

themselves, Airport

buffered =

by Mall

parking

lots Church

Reflection shows itself to mean and = highways.
primarily self-reflection, self-relation, Mall[5] Their
self-mirroring.[6] rotting

poses

no immediate

danger

to neighboring

districts.

Besides, A WEB WITHOUT A SPIDER.[7]

they are

vast

compounds,

38 not easily

erased in

an afternoon.[8]

1. McMorrough, p. 194. 2. McMorrough, p. 202. 3. McMorrough, p. 202.
4. Leong, "Ulterior Spaces," n.p. 5. Koolhaas et al., pp. 120–21.
6. Gasché, p. 13. 7. Koolhaas, "Junkspace," n.p. 8. Herman, n.p.

B Fashion

When I'm wearing heels at events, my feet feel like they're sitting in pools of blood.[1]

Emma Thompson walked on stage at the seventy-first Golden Globes with her Christian Louboutins pointedly off her feet and in her hand. Raising them in the air to demonstrate Louboutin's trademark red-lacquered soles, she quipped, "I just want you to know, this red, it's my blood."[2]

État Libre d'Orange's infamous fragrance Sécrétions Magnifiques, created by perfumer Antoine Lie, is vividly described by the company as "an olfactory coitus that sends one into raptures, to the pinnacle of sensual pleasure, that extraordinary and unique moment when desire triumphs over reason." Aside from iodised blood and milk accords, the perfume also contains notes of coconut, sandalwood and opoponax.[3]

The product takes the form of a cosmetic pill that you consume and the fragrance excretes through the skin's surface, redefining the potential of the body and giving a new function to skin. For Swallowable Parfum, the body becomes a sort of atomizer; expanding from the inside to the exterior of the body, emitting a cloud of scent around the silhouette.[4]

Kristeva uses the term "abject" to describe something that is neither object nor subject. Being an in-between state it exists in a pre-symbolic order, triggering human reactions filled with confusion about the distinction between the self and the other. A potent example of this is the reaction we encounter when faced with the human cadaver; as Kristeva points out a subject without life becomes an object, something that triggers trauma by reminding us of our own mortality. Other less extreme though highly unsettling examples apt to create similar reactions are all types of bodily fluids, human or animal, such as blood, vomit or urine.[6]

40

Collier Schorr

2002-14

Jennifer (Head)
Pigment print
56 × 40⅝ in. (142.2 × 103.2 cm)
Private collection, New York

"I can see your dirtypillows.

Everyone will.

They'll
be looking
at your
body."

41

"Those are my breasts,
Momma.
Every woman has them."[5]

1. Elizabeth Olson in Kovesi, p. 67 2. Kovesi, p. 68. 3. Harkin, p. 4.
4. Van Den Berg. 5. King, p. 142. 6. Julia Kristeva paraphrased in
Van der Toorn.

C Ancient Paris, Catacombs, Demolitions, Decline of Paris

Angelus Novus, the angel of history, staring in half-disbelief at the ruins, devastated by the failure to co-operate, made manifest in the sheer destructive capacity of technological progress.[1]

Sunlight on bare skin can be as nourishing as food.[4]

The real event of the Apocalypse is behind us, among us, and we are instead confronted with the virtual reality of the Apocalypse, with the posthumous comedy of the Apocalypse.[2]

42

Jesper Just

2013

Intercourses
Still from a five-channel
video installation
Dimensions variable
Courtesy of the artist,
Galerie Perrotin, New York and
James Cohan Gallery, New York

D Boredom, Eternal Return

What I am saying, I am the first to say *the accident is the new form of warfare*. This is enough to continue the Greco-Latin and the Judeo-Christian model. But here we are coming back to the word "apocalypse." What is the Bible? It is a book of war. It never stops in the Old Testament. The massacres never stop.[5]

That (*man*)? What? Who? *What* Paris desires is *he and that* he be condemned to death. She desires *that* (*man*) *insofar* as condemned to death and condemns him to death in desiring that (man). In a word, she makes *that* (man) desirable and decollatable.[7]

Fantasies about the ruination of Paris are a symptom of the fact that technology was not received. From these speaks the dull consciousness that with the great towns the means grew to flatten them to the ground.[3]

"Qui autem ab inferis suscitabantur praeerunt viventibus velut judices— *They, moreover, shall be raised from the depths that they shall stand above the living as judges.*"[8]

There was Henry de Béarn (1931–1995), who tried to blow up the Eiffel tower. He lived in [a] loft with Ivan Chtcheglov (1933–1998). The lights from the tower bothered them when the[y] tried to sleep, so they plotted its destruction.[6]

We wait. We are bored. (*He throws up his hand.*) No, don't protest, we are bored to death, there's no denying it. Good. A diversion comes along and what do we do? We let it go to waste. Come, let's get to work! (*He advances towards the heap, stops in his stride.*) In an instant all will vanish and we'll be alone once more, in the midst of nothingness![1]

Be bland
Be dull
Be boring
Be really, really, y'know, nothing, void, zilch, zero, nought, nothing, vacuum[3]

BOREDOM IS ALWAYS COUNTER-REVOLUTIONARY.
ALWAYS.[2]

Boredom of the ceremonial scenes depicted in historical paintings, and boredom in general. Boredom and museum. Boredom and battle scenes.[4]

"The promised land of survival will be the realm of peaceful death. …No more Guernicas, no more Auschwitzes, no more Hiroshimas.… Hooray! But what about the impossibility of living, what about this stifling mediocrity and this absence of passion?… Let nobody say these are minor details or secondary points."[5]

"Who wants a world in which the guarantee that we shall not die of starvation," Vaneigem asks, "entails the risk of dying of boredom?"[6]

Entertainment fosters the resignation which seeks to forget itself in entertainment.[7]

But then the monotony of the images we consume gets the upper hand.[9]

Les canons tonnent dans la nuit
On dirait des vagues tempête
Des coeurs où pointe un grand ennui
Ennui qui toujours se répète[8]

A man shooting heroin into his vein does so largely for the same reason you rent a video: to dodge the redundancy of time.[11]

Anyone who has felt the drive to self-destruction welling up inside him knows with what weary negligence he might one day happen to kill the organisers of his boredom.[10]

Excitement, it seems, is in reality a means to an end, a subset of what ultimately emerges as the antidote to modern boredom:

human engagement.[12]

Guido van der Werve *Nummer dertien, effugio C: you're always only half a day away*
2011 Still from a 12-hour HD video
Courtesy of the artist and
Luhring Augustine, New York

43 44

1. Leslie, p. 7 2. Baudrillard, *The Vital Illusion*, p. 36. 3. Marx, p. 105. 4. Egan. 5. Virilio and Lotringer, p. 154. 6. Wark, *The Beach beneath the Street*, p. 16. 7. Derrida, p. 75. 8. Spicer, p. 10.

1. Beckett, *Waiting for Godot*, p. 293. 2. Debord, "The Bad Old Days Will End,"
p. 36. 3. Public Image Ltd. 4. Benjamin, *The Arcades Project*, p. 859. 5. Vaneigem,
p. 35 6. Marshall, p. 551. 7. Horkheimer and Adorno, p. 113. 8. Apollinaire, p. 284
9. Vaneigem, pp. 25–26. 10. Vaneigem, pp. 42–43. 11. Joseph Brodsky in Rivenburg,
pp. 1F, 5F. 12. Ferrell.

E Haussmannization, Barricade Fighting

No replastering, the structure is rotten.[1]

The most beautiful sculpture is a paving stone thrown at a cop's head.

Commodities are the opium of the people

Write everywhere.

BURN COMMODITIES.

I participate.
You participate.
He participates.
We participate.
They profit.

If God existed it would be necessary to abolish

Don't get caught up in the spectacle of

Claire Fontaine

2007

The Barricades of May Brickbat
Brick, brick fragments, digital print,
CD-ROM
7⅞ × 5 × 2 in. (20 × 12.7 × 5.7 cm)
Collection of the artist

Art is dead, let's liberate our everyday life.

You can't buy happiness. Steal it.

Comrades, stop applauding, the spectacle is everywhere.

The economy is wounded— I hope it dies

1968

(Law of 10 May

Before writing, learn to think.

Total orgasm.

I don't like to write on the walls.

disobey; then write on the walls

abolish alienation.

Revolutionary women are more beautiful

Consciousness begins with consciousness; the beginning is disobedience.

steal.

you too can

No forbidding allowed.

punish him.

Down with spectacle- commodity communication, down with telecommunication.

Freedom is the crime that contains all crimes.

Open the gates of prisons, the asylums, and other faculties.

The future will only contain what we put into it now.

Oppose the spectacle.

Opposition.

It is our ultimate weapon.

How sad to love money.

freedom of others extends mine infinitely.

God nor master, either.

1. All quotations "May 1968 Graffiti."

F Iron Construction

wind shaking trucks, sand whipping against axles, sheet-metal; *I* soldiers clambering into trucks: RIMA squad, leaning against tarpaulin pressed down on necks by driving rain, buttoning up; eyes shining in darkening shadows, fingers glimmering on belt-buckles; goats, sweat of pursuit around bonfires soaking coats, crouching down, licking rags tied around thighs of women; silent youth wrapped in sackcloth, propped back against driver's seat, pissing into blue enamel mug held in mutilated hand: driver, leaning back, stroking youth's forehead marked with blue cross; youth kissing palm, wrist rippled with veins, swelling with alcoholic blood; half-track caterpillars grinding stones thrown onto track by wind; soldiers dozing; dye-stained members curled against thighs, dripping drops of jissom; driver of truck crowded with males, animals, bundles, spitting black saliva, wasp-sting swelling cheek, swollen half-closing eye, pockets crammed with black grapes: tanned head of old man, reddening under white hairs, shaking against sheet-metal, under gear-stick: with hobnail boots, driver, black saliva drying on chin, crushing, pulling immaculate locks from occiput, against metal beaten, from below, by cracked stones kicked back; *I* at camp, soldier: "dogs! wash out my trucks"; *I* females hanging out babies' rags on bushes; *I* males setting up tents beside rubbish ditch: sludge of rotting meat, vomit, glimmering, rosy, under lifeless reeds bending; soldiers pushing back, with butts of rifles, women laying babies down in tents; kicking, punching haunches of males bent over unrolled tarpaulins; RIMA squad pushing into den hollowed out under platform of camp in onyx vein; faces heated, arms, legs swinging, bottles thrown against walls: glass splinters falling back into darkened circle pricking, sticking to hardened members shaken out of dungarees; beer, wine—cut with bromide—splashing over shoulders, bare breasts of waiter; RIMA squad rolling, vomiting in corners; waiter, greasy shorts slipping down loins, barefoot, tattooed, on ankle, with woman's breast, trampling on floor-cloth; edging around counter, pushing cloth alongside lips of vomiting soldiers; / two males tying up animals behind tents; children, arses caked with crusts of dung, sitting on grass eroded by salt, panting, foreheads covered with dust, heads leaning lifeless on shoulders, eyes, violet-hued, watching erection of tents; soldier with curly brown hair; mouth crammed with black meat swelling pockmarked cheeks, squatting down, soiled member bouncing inside pants, beside small girl, stroking neck, hand moving down under rags covering throat, groping around breasts, under armpits: girl's eyes closing, head touching soldier's wrist smeared with grape-juice; grey drool of hun- ger running from girl's mouth onto cheek, wetting soldier's fist; / gust of wind lifting up, over mounds of excrement, pages of comics torn out by

Chris Burden <u>Tower of London Bridge</u>
 Stainless-steel Mysto Type I Erector
 parts, gearbox, wood base, edition
 of 6, with 3 AP and 1 SP
 2003 28½ × 80¼ × 8½ in.
 (72.4 × 203.8 × 21.6 cm); with base
 and gearbox: 30 × 96 × 12 in.
 (76.2 × 243.8 × 30.5 cm)
 Gagosian Gallery, New York

hands of soldiers
crouched over ditches,
forcing out tense, burning shit after
forays of rape: papers sticking to fronds
of date-palms, stench of defecated grape-juice
washing over lieutenant's zerriba: lieutenant,
crouching, naked, in tub of lukewarm water
streaked with rays filtered through lattice, whistling, medallion balanced on tip of tongue,
neck-chain held on mounds of swollen cheeks, purplish glans touching grape-tinted
foam, farts bubbling at sides of bronze tub, forcing rhythm of whistling; / soldiers—on
mainland: dance-hall bouncers—, in fading light, prowling around tents, untying thongs,
crawling on sand, tent-flaps rubbing over backs riddled with scabies; males, females,
nerves phosphorescent, huddling together around candles, youths, ears buried, chewing
raw semolina straight from sacks; children pulling aside, with pinched lips, clenched
teeth, rags covering, containing breasts of women, licking half-chewed flour from lips of
youths; soldiers, tugging at girls' naked legs; father grabbing candle; curly-haired soldier,
rolling black meat in vermilion mouth, unsheathing dagger: soldier's hand, quick, cov-
ering vulva buried under scarlet rags, grabbing, pinching; soldier pulling thigh, drawing
sleeping girl[1]

1. Guyotat, pp. 2–3.

G Exhibitions, Advertising, Grandville

THE PINK ELEPHANTS

LONDON DRY
Felt a trifle queer last night
couldn't eat a thing
couldn't drink a think.
Lay very still for a few minutes.
Drank a lot and later quite
made up for it all.

Who said Gin?

DOM PERIGNON
Made a fair number
of decisions in the bar last
night. Carried them all out
and went home happy and
diagonal.

Stagger stagger...

THE MAJORS PORT
Had two dizzy spells
at lunch today.
Asked the two identical waiters
to bring us a couple of doubles
for the second time.
Felt twice as good.

Is that a treble?

BRISTOL CREAM
Nice beano last night—
Awoke this morning
feeling absolutely marvellous
must be some road
repairs going on nearby as
there is this terrible sound
Of drilling.

VVVvvvvvvvvvv

THE MAJORS PORT
After a certain number of
glasses of a certain
drink, certain people prefer
to ride in the front
of the cab.

You o.k. Sir?

LONDON DRY
We dropped by at quite a
number of places of refreshment
last evening and everyone
seemed very friendly and
flighty on the whole.

Whoops!

BRISTOL CREAM
Went up to the bar and ordered
these drinks, lost those
somewhere ordered a couple more,
found that we had forgotten
the others so we had another
round, found some and tended
to lost track a shade.

Wonderful Stuff!

DOM PERIGNON
There's not an awful
lot to be said for the
case of getting home
in time sometimes.

Early Days.[1]

Raymond Hains Martini
 Plexiglas relief
 1968 72 × 105.9 in. (183 × 269 cm)
 Galerie Max Hetzler, Paris

1. Gilbert and George, p. 75.

H The Collector

No collector
whose activities
were purely
speculative
would be taken
seriously in the
long term.[2]

It's all about quantity. Just like you, I'm drowning in my riches. I've got more music on my drives than I'll ever be able to listen to in the next ten lifetimes. As a matter of fact, records that I've been craving for years . . . are languishing unlistened-to. I'll never get to them either, because I'm more interested in the hunt than I am in the prey. The minute I get something, I just crave more. And so something has really changed—and I think this is the real epiphany: the ways in which culture is distributed has become profoundly more intriguing than the cultural artifact itself. What we've experienced is a inversion of consumption, one in which we've come to prefer the acts of acquisition over that which we are acquiring, the bottles over the wine.[1]

"Everything remembered, everything thought, everything conscious. . . ."

[Collectors] know not all live performances are good and not all bootlegs are high quality. You [may] get a person not knowing what to expect picking up a piece of bad product and being turned off forever, whereas a knowledgeable person knows that this could very well have been recorded in the men's washroom at the back of the arena but that's OK because it has a version of this song that has never been played before and that's fine.[4]
Cab to Alkit Camera ($3) on 53rd and Third. The cab driver didn't even turn around to look at me but he knew who I was. I asked him how he could tell. He said that he'd been buying art since he was twenty and just "tacking it around the house like the Collyer Brothers." He went to auctions and places for art bargains, and he was thrilled to have me in the cab. I got a new camera because I had to take pictures of Chrissie Evert later in the afternoon. For the Athletes series.[5]

Cindy Sherman

2008

Untitled #474
Chromogenic print
91 × 60¼ in. (231.1 × 153 cm)
Collection of Cynthia
and Abe Steinberger

Intervals register only when their
background has a sufficiently

inclusive,

expansive extension

and duration.[3]

1. Goldsmith, "Epiphany," p. 77. 2. Graw, p. 100.
3. Dworkin, "Zero Kerning," p. 15. 4. Heylin, p. 9.
5. Warhol, n.p.

I The Interior, The Trace

Though now even less than ever given to wonder he cannot but sometimes wonder if it is indeed to and of him the voice is speaking. May not there be another with him in the dark to and of whom the voice is speaking? Is he not perhaps overhearing a communication not intended for him? If he is alone on his back in the dark why does the voice not say so? Why does it never say for example, You saw the light on such and such a day and now you are alone on your back in the dark? Why? Perhaps for no other reason than to kindle in his mind this faint uncertainty and embarrassment.[1]

This is the set-up of the motionless voice—a voice *put under house arrest* by a body [*qu'un corps assigne à residence*][2]

I have no voice and must speak, that is all I know.[3]

(fight fight talk talk ... talk talk fight fight)

shift lingual . . .
free doorways . . .
pinball age
tangles . . .
free cone agent
dim blot . . .
scribble electric
voice eyes . . .
voice of
c cone . . .
out of
doorways . . .
tangles
voices . . .
tata Stalin . . .
carriage age tar . . .
vibrate tourists . . .
cover Zen
terminals . . .
pinball machines
led streets . . .
with elect of
doorways . . .
doorway grind
enclosures of hatch[6]

My body does not yet make up its mind. But I fancy it weighs heavier on the bed, flattens and spreads. My breath, when it comes back, fills the room with its din, though my chest moves no more than a sleeping child's.

Possessed of nothing but my voice, the voice, it may seem natural, once the idea of obligation has been swallowed,

I open my eyes and gaze unblinkingly and long at the night sky.[4] Shakespeare [and] Rimbaud live in their words. Cut the word lines and you will hear their voices.[5]

that I should interpret it as an obligation to say something. But is it possible?

54

Simon Evans

2010

The Voice
Mixed media on paper
44 × 44 in. (111.8 × 111.8 cm)
Alka and Ravin Agrawal

1. Beckett, "Company," pp. 6–7. 2. Badiou, p. 10. 3. Beckett, "The Unnamable," p. 301.
4. Beckett, *Malone Dies*, p. 22. 5. Burroughs, "The Cut-Up Method of Brion Gysin," n.p.
6. Burroughs, "Cut-Up of Prose Poem 'Stalin' by Sinclair Beiles," n.p.
7. Beckett, "The Unnamable," p. 305.

J Baudelaire

You want to know why I hate you?[1]
Well I'll try and explain . . .
You remember that day in Paris
When we wandered through the rain
And promised to each other
That we'd always think the same
And dreamed that dream
To be two souls as one
And stopped just as the sun set
And waited for the night
Outside a glittering building
Of glittering glass and burning light . . .

And in the road before us
Stood a weary greyish man
Who held a child upon his back
A small boy by the hand
The three of them were dressed in rags
And thinner than the air
And all six eyes stared fixedly on you

The father's eyes said "Beautiful!
How beautiful you are!"
The boy's eyes said
"How beautiful!
She shimmers like a star!"
The childs eyes uttered nothing
But a mute and utter joy
And filled my heart with shame for us
At the way we are

Mary Reid Kelley Charles Baudelaire
 Pigment ink print
 2013 22½ × 16⅛ in. (57 × 41 cm)
 Courtesy of the artist
 and Arratia Beer, Berlin

I turned to look at you
To read my thoughts upon your face
And gazed so deep into your eyes
So beautiful and strange
Until you spoke
And showed me understanding is a dream
"I hate these people staring!
Make them go away from me!"

The father's eyes said "Beautiful!
How beautiful you are!"
The boys eyes said
"How beautiful! She glitters like a star!"
The child's eyes uttered joy
And stilled my heart with sadness
For the way we are

57

1. The Cure, inspired by and based
on Charles Baudelaire's poem
"The Eyes of the Poor."

K Dream City and Dream House, Dreams of the Future, Anthropological Nihilism, Jung

DAYLIGHT ALL NIGHT LONG.[1]

The scientific quest here is not to find ways of stimulating wakefulness but rather to reduce the body's *need* for sleep.

The sleeplessness research should be understood as one part of a quest for soldiers whose physical capabilities will more closely approximate the functionalities of non-human apparatuses and networks.

24/7 markets and a global infrastructure for continuous work and consumption have been in place for some time, but now a human subject is in the making to coincide with these more intensively.

```
              T    24/7 is a static redundancy that        t
              h          disavows its relation             i
              e       to the rhythmic and periodic          m
                         textures of human life.           e

              e
Sleep will    m    always collide with the demands of      o    a 24/7 universe.
              p                                             f
      An      t    illuminated 24/7 world without               shadows
      is      y,   the final capitalist mirage of post-    m    history,
      of           an exorcism of the otherness that is the o   motor
      of      h    historical change.                      d
              o                                             e
              m                                             r
24/7 is a time of o                                         n
              g    indifference, against which the          i    inadequate
              e    fragility of human life is              t    and within
              n    increasingly                            y.   which sleep has
              o                                                  no necessity or
              u    Carlyle:                                      inevitability.
              s    "Over our noblest faculties
                   is spreading a nightmare sleep."
```

Mike Kelley

2010-13

Mobile Homestead Swag Lamp
Aluminum, steel, lighting fixtures, wiring
18 × 25½ × 17⅝ in.
(45.7 × 64.8 × 44.7 cm)
Museum of Contemporary Art, Detroit, and the Mike Kelley Foundation for the Arts

Sleep is an uncompromising interruption of the theft of time from us by capitalism.

The machine-based designation of "sleep mode,"
. . . a state of low-power readiness.

. . . It supersedes an off/on logic, so that nothing is ever fundamentally "off" and there is never an actual state of rest.

24/7 steadily undermines distinctions between day and night, between light and dark, and between action and repose. It is a zone of insensibility, of amnesia, of what defeats the possibility of experience.

In experiments,

r
a
t
s

w
i
l
l

d
i
e

a
f
t
e
r

r

At Guantánamo . . .

inmates are required to live in windowless cells that are always lit, and they must wear eye and ear coverings that block out light and sound whenever they are escorted out of their cells to preclude any awareness of night and day.

Debord:
"The spectacle expresses nothing more than society's wish for sleep."

Emerson:
"Sleep lingers all our lifetime about our eyes."

two to three weeks of sleeplessness.

1. All quotations Crary.

L Dream House, Museum, Spa

 h r l t o s i
M c o o r o k a f c s d n t e e a i n h p of the media to time, or on time directly.
 u h f u w r h s o u e o

 M l d
 e o y

 does not exist at all (The Disappearance of Melody)
unless one is forced to hear the movement from group to group
 of various simultaneously sounded frequencies derived from
the overtone series as melodic because of previous musical o d t o i g
 c n i i n n
 .

 By 1962 La Monte had formulated the concept of a
 Dream House

 in which a work would be played continuously and ultimately
 exist in time as a "living organism with a life and tradition of
 its own."

In Dream Music there is a radical departure from European and even much
Eastern music in that the basis of musical relationship is entirely a m n
 h r o y.

James Welling

2014

Morgan Great Hall
Inkjet print, edition of 5
21 × 31.5 in. (53.3 × 80 cm)
Wadsworth Atheneum, Hartford

A continuous frequency environment in sound and light with singing from time to time.[1]

Each of the intervals and chords is selected beforehand from "The Two Systems of Eleven Categories 1:07:40 AM 3 X 67 –" (first revision of "'2–3 PM 12 XI 66 – 3:43 AM 28 XII 66 for John Cage' from 'Vertical Hearing, Or Hearing in the Present Tense'").

the information will be given to people who telephone.

Careful placement of light sources, and use of dichroic filters to create intense, near-pure colors, secondary and tertiary shadows.

Once a situation is created in which the artists may sing several hours a day, several days a week, for a few weeks, it no longer seems important to fix an auspicious evening at 20h two months or six months in the future.

No predetermined singing times will be set, rather the artists plan to sing frequently during the 10 to 18 hours, Monday through Saturday, and later on some days, for the duration of the show. If it should be known at any point in advance that they will sing at a particular time

It last[s] forever and cannot have begun but is taken up again from time to time until it lasts forever as continuous sound in Dream Houses where many musicians and students will live and execute a musical work.

This music may play without stopping for thousands of years, just as the Tortoise has continued for millions of years past.

1. All quotations Young and Zazeela.

61

62

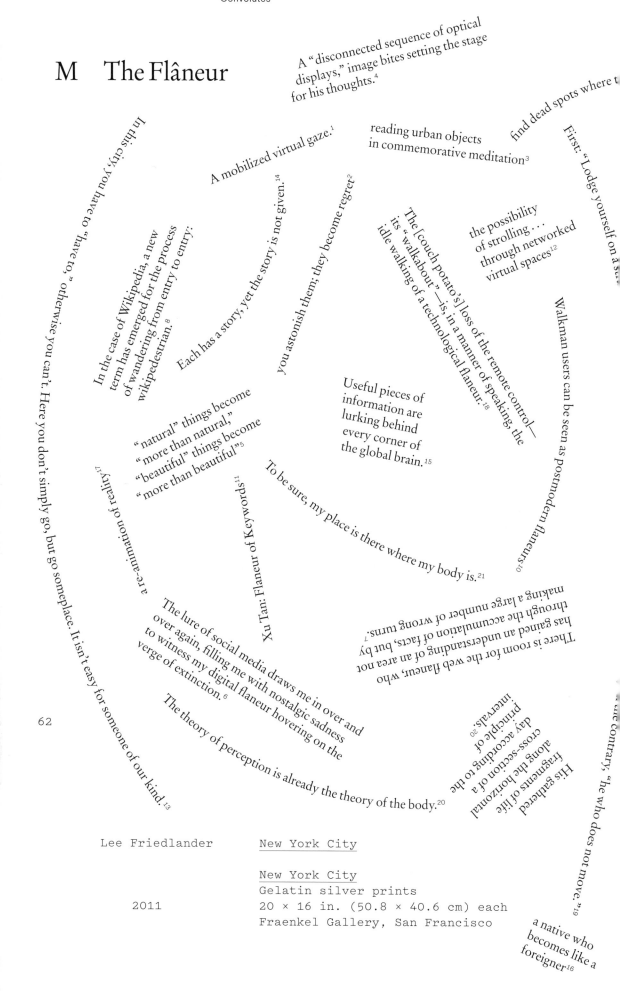

M The Flâneur

A "disconnected sequence of optical displays," image bites setting the stage for his thoughts.[4]

find dead spots where t…

First: "Lodge yourself on a s…

reading urban objects in commemorative meditation[3]

A mobilized virtual gaze.[1]

the possibility of strolling… through networked virtual spaces[12]

In this city, you have to "have to," otherwise you can't. Here you don't simply go, but go someplace. It isn't easy for someone of our kind.[13]

a re-animation of reality[17]

Each has a story; yet the story is not given.[14]

you astonish them; they become regret[2]

The [couch potato's] loss of the remote control—its "walkabout"—is, in a manner of speaking, the idle walking of a technological flaneur.[18]

Walkman users can be seen as postmodern flaneurs[20]

In the case of Wikipedia, a new term has emerged for the process of wandering from entry to entry: wikipedestrian.[8]

"natural" things become "more than natural," "beautiful" things become "more than beautiful"[5]

Useful pieces of information are lurking behind every corner of the global brain.[15]

To be sure, my place is there where my body is.[21]

Xu Tan: Flaneur of Keywords[11]

The lure of social media draws me in over and over again, filling me with nostalgic sadness to witness my digital flaneur hovering on the verge of extinction.[6]

There is room for the web flaneur, who has gained an understanding of an area not through the accumulation of facts, but by making a large number of wrong turns.[7]

The theory of perception is already the theory of the body.[20]

His gathered fragments of life cross-section of a day according to the horizontal principle of the interval.[20]

the contrary; "he who does not move.[19]

a native who becomes like a foreigner[16]

Lee Friedlander New York City

New York City
Gelatin silver prints
2011 20 × 16 in. (50.8 × 40.6 cm) each
Fraenkel Gallery, San Francisco

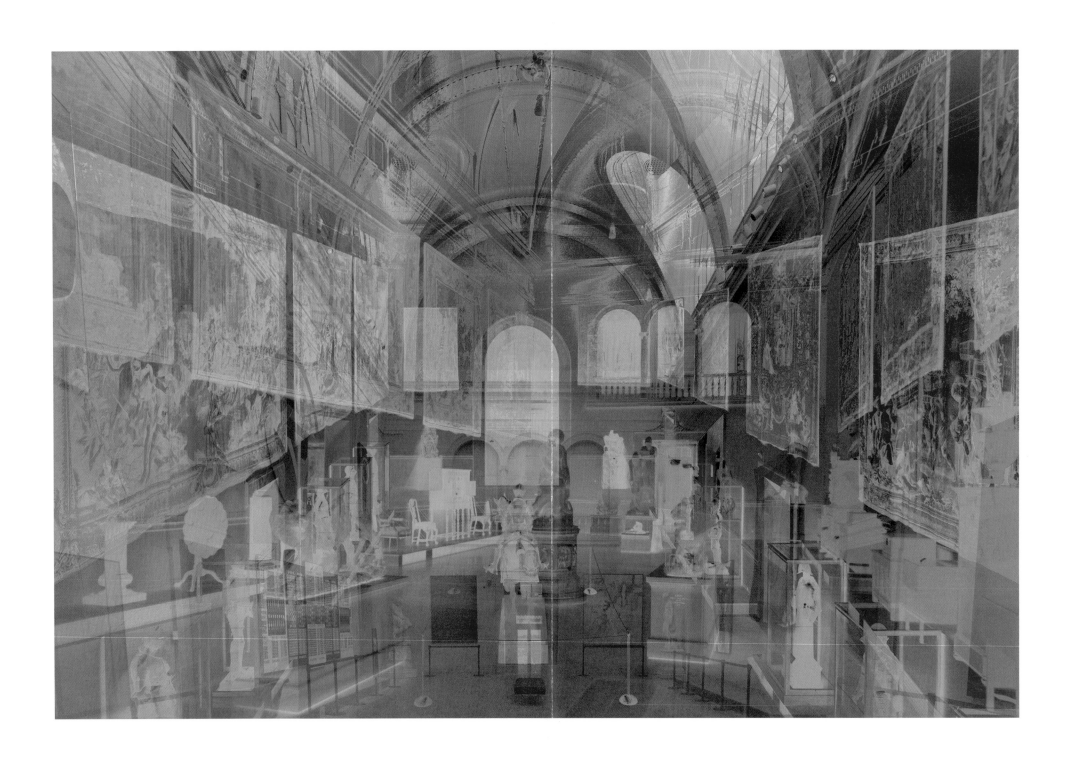

ignals can't be picked up[9]

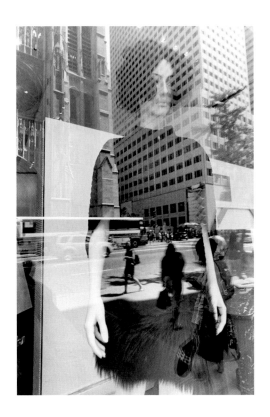 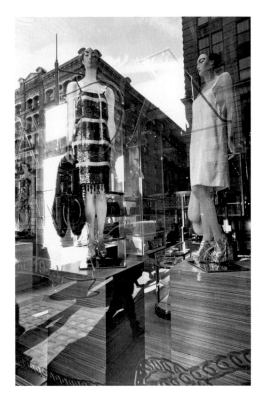

63

1. Skoller, p. 12. 2. Dworkin, *Motes*, p. 11. 3. Huyssen, p. 50. 4. Lippard, p. 40. 5. Foucault, *The Politics of Truth*, p. 108. 6. Goldsmith, *Wasting Time on the Internet*, p. 66. 7. Halavais, n.p. 8. Halavais, n.p. 9. Coyne, p. 167. 10. Erlmann, p. 7. 11. Xu, p. 168. 12. Grau, p. 257. 13. Large, p. 189. 14. Green, p. 12. 15. Mager, p. 38. 16. Holmes, p. 198. 17. Holmes, p. 198. 18. Cooper, p. 58. 19. Poster and Savat, p. 64. 20. Graf, p. 88. 21. Gardner, p. 109.

N On the Theory of Knowledge, Theory of Progress

Method of this project: literary montage. I needn't say anything. Merely show. I shall purloin no valuables, appropriate no ingenious formulations. But the rags, the refuse—these I will not inventory but allow, in the only way possible, to come into their own: by making use of them.[1]

– No one anywhere really says "You needn't."
 Just remove it from your active vocabulary
– Really?? Even in such contexts [as]
 "Shall I put those bags in the trunk?"
 "No, you needn't, thank you."
– You needn't discard this phrase, it's still active in the UK, although not so common nowadays.
– You should know about this construction passively, though you needn't stress about using it right.
– Humble: In American English at least . . . :
 "Shall I put those bags in the trunk?"
 "No, you don't need to, thank you."
 In American English, that SHALL is optional
 (or obsolete for many youngsters) too.
– If the SHALL is optional, what would you say then? I mean without SHALL.
– Should or going to is normally used, not shall.
– "I don't need a pen" or
 "I needn't a pen."
 Is it used in this context? I don't know, but I don't use "needn't."
– Should or going to is normally used, not shall.[2]

Kansas City,
Kansas,
proves that
even Kansas City
needn't always be
Missourible.[5]

You're talking so sweet
Well you needn't
You say you won't cheat
Well you needn't
You're tapping your feet
Well you needn't
It's over now
It's over now[4]

"Well, You Needn't" is a jazz standard composed by Thelonious Monk in 1944. . . . The title was inspired by a protégé of Monk's, the jazz singer Charlie Beamon: Monk wrote a song and told Beamon he was going to name it after him, to which Beamon apparently replied "Well, you need not."[3]

64

Taryn Simon

Folder: Swimming Pools

Folder: Handshakes
Archival inkjet prints
2012
47¼ × 62¼ in. (120 × 158.1 cm) each
Courtesy of the artist and Gagosian

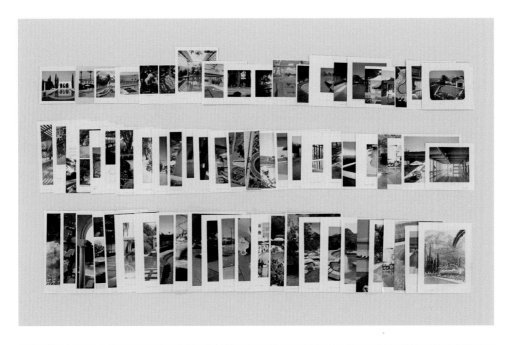

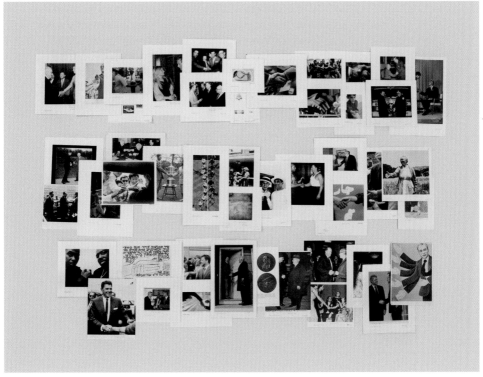

1. Benjamin, *The Arcades Project*, p. 460.
2. " 'You Don't Need' vs. 'You Needn't.' "
3. "Well, You Needn't." 4. McRae. 5. Nash.

O Prostitution, Gambling

The gambling room is always very dark. . . . The combination of darkness and enclosure of the gambling room and its subspaces makes for privacy, protection, concentration, and control. The intricate maze under the low ceiling never connects with outside light or outside space. This disorients the occupant in space and time. One loses track of where one is and when it is. Time is limitless, because the light of noon and midnight are exactly the same. Space is limitless, because the artificial light obscures rather than defines its boundaries. . . . Light is not used to define space. Walls and ceilings do not serve as reflective surfaces for light but are made absorbent and dark. Space is enclosed but limitless, because its edges are dark. Light sources, chandeliers, and the glowing, jukeboxlike gambling machines themselves are independent of walls and ceilings. The lighting is antiarchitectural. illuminated *baldacchini*, more than in all Rome, hover over tables in the limitless shadowy restaurant at the Sahara Hotel.[1]

Starting all over again is the regulative idea of the game.[6]

Gambling itself is a desert form, inhuman, uncultured, initiatory, a challenge to the natural economy of value, a crazed activity on the fringes of exchange. But it too has a strict limit and stops abruptly; its boundaries are exact, its passion knows no confusion. Neither the desert nor gambling are open areas; their spaces are finite and concentric, increasing in intensity toward the interior, toward a central point, be it the spirit of gambling or the heart of the desert—a privileged, immemorial space, where things lose their shadow, where money loses its value, and where the extreme rarity of traces of what signals to us there leads men to seek the instantaneity of wealth.[2]

What's your game? . . .
Speculation I believe.[3]

```
Rodney Graham          Good Hand Bad Hand
                       Two painted aluminum lightboxes
                       with transmounted chromogenic
                       transparencies
          2010         35¼ × 29¼ × 7 in.
                       (89.5 × 74.3 × 17.8 cm) each
                       Kadist, San Francisco
```

1ST, Judgment
or knowledge;

2D, Nerve;

*imaginaire
économique*[5]

3D, Money;

I shall *suddenly* know whether
I have won or lost.[7]

4TH, Patience.[11]

"Un Coup de Dés Jamais N'Abolira
Le Hasard"[8]

luxury of a
permanent thrill.[4]

Gambling isn't exactly a passion:
the pleasure one derives from it is too
crystalline. It is a cold ecstasy which deals
with money not as meaning, value, depth
or substance, but in the pure form of
appearance or disappearance.[10]

*Quant à l'idée d'établir un
rapport direct entre littérature et arts
plastiques j'ai peur l'avoir fait
en prenant comme sujet Le Coup de
Dés, de Mallarmé!!!*[9]

1. Venturi, Scott Brown, and Izenour, p. 49. 2. Baudrillard, *America*, p. 128.
3. Austen, p. 161. 4. Lacour-Gayet, p. 159. 5. Desan. 6. Benjamin,
Charles Baudelaire, p. 137. 7. Stäheli, *Spectacular Speculation*, p. 26.
8. Mallarmé, "Un Coup de Dés Jamais N'Abolira Le Hasard." 9. Broodthaers,
p. 27. 10. Baudrillard, *Baudrillard Live*, p. 107. 11. Moore, p. 42.

P The Streets of Paris

Jorge Macchi

2007

La Ciudad Luz (The Light City)
Lamp, table, map, digital print
on paper
78¾ × 78¾ × 118⅛ in.
(200 × 200 × 300 cm)
Collection Inhotim, Brumadinho,
Brazil

Ainsi les grandes convulsions pas encore entièrement apaisées

trouvé les seins de Barbara

Barbara s'est mise à hurler

Ce geste même est inutile

"Laissons les morts enterrer les morts,
et les plaindre … Notre sort sera d'être
les premiers à entrer vivant dans
la vie nouvelle."
—Marx, *Lettre à Ruge*.[1]

Le dessin non plus n'est pas très clair, et les amateurs d'histoires bien

—Ce désir désespéré

Quelques instants l'un près de l'autre

Après boire

—Oh! Barbara, depuis

à "épater"

—Je voudrais le sable mouvant

uos

faire de cette nuit, qui, pour

bouclées en seront pour leurs frais: le récit commence un peu au hasard et se termine de même

N'est-ce pas hier boire A quoi penses-tu?

les sollicitations d'un passé qui ne peut revivre que dans le souvenir, ou dans une "répétition," où, quoi qu'on fasse, il se dégradera

jours à venir, nous assurera une

elle avait dix-sept ans

dans les labyrinthes pierreux d'une capitale

—Oui

Parmi tant de fragilités?

69

désir

atie souveraine et l'empire absolu

Barbara marche à l'avant

Et maintenant

La matière est riche et les directions multiples

Quel âge avions-nous alors?

Elle brûle du même

Combien de fois

en "enfants perdus"

hantises et désirs toujours vivants

criture des dialogues Le pouvoir est entre nos mains

1. All quotations Debord, "Juin 1952."

Q Panorama

The panorama was historically
"the first optical mass medium."[4]

A film is an emotional reality, and that is how the audience receives it— as a second reality. The fairly widely held view of cinema as a system of signs therefore seems to me profoundly and essentially mistaken.[6]

The city viewed from ground level, where its functions and forces are concentrated, is a city of fractured, autonomous, and localized views.[1] But false fronts are of the order and scale of Main Street. From the desert town on the highway in the West of today, we can learn new and vivid lessons about an impure architecture of communication. The little low buildings, gray-brown like the desert, separate and recede from the street that is now the highway, their false fronts disengaged and turned perpendicular to the highway as big, high signs. If you take the signs away, there is no place. The desert town is intensified communication along the highway.[2] The old landscape of naturalism and realism is being replaced by the new landscape of abstraction and artifice.[3] A darkened room, where the spectators, like Plato's cave-dwellers, are virtually held captive between the screen and the projection room, chained to their cinema seats, positioned between the large-size rectangle on which the fleeting illusions of motion appear,

70

Nicholas Buffon

The Bar Downstairs
Foam, glue, paper, paint
56 × 25 × 5 in. (142.2 × 63.5 × 12.7 cm)

FDR 99 Cent Slice Pizza
Foam, glue, paper, paint
20½ × 13 × 12½ in. (52.1 × 33 × 31.8 cm)
Rubell Family Collection, Miami,
courtesy of the artist and
Callicoon Fine Arts, New York

2016

(panorama = drug of consciousness, consciousness as drug)[9]

and the devices that produced the images of darkness and light.[5] Teleview (1921) introduced the 3-D film to the United States. Colorful light projections, viewed with two-color glasses, created impressions of space and depth. Like the panorama, the subjects of these films were distant and, for the average urban American, exotic places: a Hopi camp in Arizona, scenes from the Canadian Rockies.[7] The panorama is paradoxical: topographically "complete" while still signalling an acknowledgement of and desire for a greater extension beyond the frame. The panoramic tableau, however bounded by the limits of a city profile or the enclosure of a harbor, is always potentially unstable: "If this much, why not more?" The psychology of the panorama is overtly sated and covertly greedy, and thus caught up in the fragile complacency of disavowal. The tension is especially apparent in maritime panoramas, for the sea always exceeds the limits of the frame.[8]

71

1. Dubbini, p. 189. 2. Venturi, Scott Brown, and Izenour, p. 18.
3. Smithson, "Aerial Art (1969)," p. 116. 4. Oettermann, p. 9.
5. Zielinski, p. 92. 6. Tarkovsky, p. 176. 7. Grau, p. 153. 8. Sekula, p. 43. 9. Barthes, p. 165.

R Mirrors

But your eyes proclaim
That everything is surface. The surface is what's there
And nothing can exist except what's there.[3]

The mirror itself is not subject
to duration, because it is an ongoing abstrac-
tion that is always available and timeless. The
reflections, on the other hand, are fleeting instances that evade
measure. Space is the remains, or corpse,
of time, it has dimensions.[1]

Indeed, for
the *imagos*—whose veiled faces it is
our privilege to see in outline in our daily experience
and in the penumbra of symbolic efficacity—the mirror-image
would seem to be the threshold of the visible world, if we go by
the mirror disposition that the *imago of one's own body* presents
In short, in hallucinations or dreams, whether it concerns its individual
every mirror features, or even its infirmities, or its object-projections; or if we
de-realises observe the role of the mirror apparatus in the appearances of the
its object *double*, in which psychical realities, however heterogeneous, are
insinuating manifested.[2]
some doubt
upon the
situation, *Le livre,*
upon its *dans son ambition,*
nature.[6] *se voulait le livre du regard. L'être,* *la chose*
n'existent que dans le miroir qui les contrefait. Nous sommes les
innombrables facettes de cristal où le monde se reflète et nous
renvoie à nos reflets, de sorte que nous ne pouvons nous connaître
qu'à travers l'univers et le peu qu'il a retenu de nous.[4]

Certainly there is still a presence of
Midnight. The hour has not disappeared through a mirror,
has not been buried in draperies, evoking a furnishing by its vacant
sonority. I remember that its gold was about to feign, in absence, a null jewel of
reverie, a rich and useless survival, except that over the marine and stellar complexity of
a goldsmith's was the infinite chance of conjunctions to be read.[7]

Mungo Thomson
June 25, 2001 (How the Universe
Will End) March 6, 1995 (When Did
the Universe Begin?)
Installation, enamel on low-iron
mirror, poplar, anodized aluminum
2012
Two panels, 74 × 56 × 2½ in.
(188 × 142.2 × 6.4 cm) each
Kadist, San Francisco

No, no, don't look at yourself.[9]

Dada, o Dada, what a face! so sad as all that? so merry? Look at yourself in the mirror.

In a single mirror or a single pupil is found the image of all the objects placed before it, and each of these objects is complete in the complete surface of the mirror and complete in each of its least parts.[5]

Many a time the mirror imprisons them and holds them firmly. Fascinated they stand in front. They are absorbed, separated from reality and alone with their dearest vice, vanity. . . . There they stand and stare at the landscape which is themselves, the mountains of their noses, the defiles and folds of their shoulders, hands, and skin, to which the years have already so accustomed them that they no longer know how they evolved; and the multiple primeval forests of their hair. They meditate, they are content, they try to take themselves in as a whole.[8]

1. Smithson, "Incidents of Mirror-Travel in the Yucatán (1969)," p. 122.
2. Lacan, "The Mirror Stage," p. 3. 3. Ashbery, p. 70. 4. Jabès, p. 51.
5. Leonardo da Vinci in Schefer, pp. 24, 197. 6. Paris, p. 249. 7. Mallarmé,
Igitur, Divagations, Un Coup de Dés, p. 59. 8. Sélavy [Duchamp], p. 188.
9. Ribemont-Dessaignes, p. 19.

S Painting, Jugendstil, Novelty

They were infantrymen, and know how to snooze between
footfalls—at some hour of the morning they will fall out by the side
of the road, a moment's precipitate out of the road chemurgy
of these busy nights, while the invisible boiling goes on by,
the long strewn vorti- ces—pinstripe suits with crosses painted
on the back, ragged navy and army uniforms, white turbans,
mismatched socks or none, Tattersall dresses, thick-knitted
shawls with babies inside, women in army trousers split at the knees,
flea-bitten and barking dogs that run in packs, prams piled
high with light furnishings in scarred veneer, hand-mortised
drawers that will never fit into anything again, looted chickens
alive and dead, horns and violins in weathered black cases,
bedspreads, harmoniums, grandfather clocks, kits
full of tools for carpentry, watchmaking, leatherwork,
surgery, paintings of pink daughters in white frocks, of saints
bleeding, of salmon and purple sunsets over the sea, packs stuffed
with beady-eyed boas, dolls smiling out of violently red lips,
Allgeyer soldiers an inch and a quarter to the man painted cream,
gold and blue, handfuls of hundred-year-old agates soaked in honey
that sweetened greatgrand- father tongues long gone to dust, then
into sulfuric acid to char the sugar in bands, brown to black, across
the stone, deathless piano performances punched on Vorsetzer
rolls, ribboned black linge- rie, flowered and grape-crested
silverware, faceted lead- glass decanters, tulip-shaped Jugendstil
cups, strings of amber beads ... so the populations move,
across the open meadow, limping, marching, shuffling,
carried, hauling along the detritus of an order, a European
and bourgeois order they don't yet know is destroyed forever.[1]

Sanya Kantarovsky

The Master Is Released: Behemoth cut himself a slice of pineapple, salted and peppered it, ate it and chased it down with a second glass of spirit with a flourish that earned a round of applause

Oil, oilstick, pastel, watercolor on canvas

2015

110¼ × 71 in. (280.7 × 180.3 cm)
Private collection

1. Pynchon, pp. 550–51.

T Modes of Lighting

lighght[1]

Among the kinds of light that might be seen now
might be
arc-light
watch-light light
jump-spark igniter light
Aufklärung
lightning
rays of light
cold light
moonlight
naphtha-lamp light
noontide light
luminiferousness
almandite light
enameling-lamp light
a nimbus
meteor light
Jack-o'-lantern light
water lights
jack-light light
refracted light
altar light
Corona-cluster light
magic lantern light
ice-sky light
clear grey light
iridescence
natural light
infra-red light
Reichsanstalt's lamplight
exploding-starlight

Saturn light
Earthlight
actinism
sodium-vapor lamplight
cloud light
Coma-cluster light
alcohol lamplight
luster
light of day &/or
lamplight.

One of these kinds of light might be seen now
or
some other kind of light.[3]

Come shadow, come, and take this shadow up,
Come shadow shadow, come and take this up,
Come, shadow, come, and take this shadow up,
Come, come shadow, and take this shadow up,
Come, come and shadow, take this shadow up,
Come, up, come shadow and take this shadow,
And up, come, take shadow, come this shadow,
And up, come, come shadow, take this shadow,
And come shadow, come up, take this shadow,
Come up, come shadow this, and take shadow,
Up, shadow this, come and take shadow, come
Shadow this, take and come up shadow, come
Take and come, shadow, come up, shadow this,
Up, come and take shadow, come this shadow,
Come up, take shadow, and come this shadow,
Come and take shadow, come up this shadow,
Shadow, shadow come, come and take this up,
Come, shadow, take, and come this shadow, up,
Come shadow, come, and take this shadow up,
Come, shadow, come, and take this shadow up.[4]

Cerith Wyn Evans

2011

Witness (after Iannis Xenakis)
Chandelier (Luce Italia), independent
breather unit, flash player
70⅞ × 47¼ in. (180 × 120 cm) high
Courtesy of the artist and
White Cube, London

1. Saroyan. 2. Solt, p. 41. 3. Mac Low, p. 16.
4. Zukofsky, p. 219.

U Saint-Simon, Railroads

We shall sing the great masses shaken with work, pleasure, or re-
bellion: we shall sing the multicolored and polyphonic tidal waves
of revolution in the modern metropolis; shall sing the vibrating
nocturnal fervor of factories and shipyards burning under violent
electrical moons; bloated railroad stations that devour smoking
serpents; factories hanging from the sky by the twisting threads of
spiraling smoke; bridges like gigantic gymnasts who span rivers,
flashing at the sun with the gleam of a knife; adventurous steam-
ships that scent the horizon, locomotives with their swollen chest,
pawing the tracks like massive steel horses bridled with pipes, and
the oscillating flight of airplanes, whose propeller flaps at the wind
like a flag and seems to applaud like a delirious crowd.[1]

Even the Rhine appears to be something at our command. . . . The
river is dammed up into the power plant. What the river is now,
namely a waterpower supplier, derives from the essence of the
power station.[3]

An ordinary man can in a day's time travel by train from a little
dead town of empty squares . . . to a great capital city bristling with
lights, gestures and street cries. By reading a newspaper the inhab-
itant of a mountain can tremble each day with anxiety, following
insurrection in China, the London and New York suffragettes.
. . . The timid, sedentary inhabitant of any provincial town can
indulge in the intoxication of danger by going to the movies and
watching a great hunt in the Congo.[4]

What does "here" mean on the phone, on television, at the receiver
of an electronic telescope. And the "now"? Does not the "tele-"
element necessarily destroy presence, the "here and now" of the
forms and their "carnal" reception? What is a place, a moment,
not anchored in the immediate "passion" of what happens? Is a
computer in any way here and now? Can anything *happen* with
it? Can anything happen *to* it?[5]

78

Martín Ramírez Untitled (Trains and Tunnels), A, B
 Gouache, graphite on paper
 1960-63 19 × 76½ in. (48.3 × 194.3 cm)
 Private collection

The problem is knowing whether the Master-Slave conflict will find its resolution in the service of the machine.[2]

79

1. Marinetti, "The Manifesto of Futurism," pp. 51–52. 2. Lacan, "Aggressivity in Psychoanalysis," p. 30. 3. Heidegger, p. 329. 4. Marinetti, "Destruction of Syntax—Imagination without Strings—Words-in-Freedom," p. 96. 5. Lyotard, p. 118.

V Conspiracies, *Compagnonnage*

The gross floor space of Taipei 101 is about 1,000,000 cubic meters. The volume of the Black Sea is 131,200 cubic miles. So the volume of the Taipei 101 is .315% of the volume of the Black Sea, meaning that the splash resulting from dropping the one into the other will be large on a human scale, but relatively small on the scale of the inhuman, that of seas and buildings. Unless dropped from a great height. The Sikorsky CH-54 Tarhe is a twin-engine heavy-lift helicopter designed by Sikorsky Aircraft for the United States Army. It can lift 20,000 pounds. Considering that the Taipei 101 weighs 700,000 metric tons, it would require at least 77,161 Sikorsky CH-54 Tarhes to lift the building and suspend it over the Black Sea at, say, 15,000 feet. Dropping Taipei 101 into the Black Sea from 15,000 feet would produce an enormous splash, on a human scale. The resulting waves would certainly pummel nearby shores for hours, if not days. Swimming in the choppy waters would be unadvisable. In this way one could, if one wanted to—say, if one were representative of a governmental body concerned with illegal entry to one's country by water, or if, say, one just wanted to put an end to swimming for their own nihilistically personal reasons—count all swimmers out, at least from the water immediately affected by the splash. One would need many more Sikorsky CH-54 Tarhes dropping many more Taipei 101s if one wanted to empty the entire Black Sea of swimmers. Still, even if 77,161,000 Sikorsky CH-54 Tarhes were to drop 1,000 Taipei 101s from 15,000 feet each, which would go a long way, I think, toward getting swimmers out of the water, one way or another, after which getting out they would no longer be swimmers, nothing would be shattered.[1]

Voluspa Jarpa

2013

What You See Is What It Is
Steel modules, laser-cut
acrylic plates
116½ × 24 × 43¼ in.
(295.9 × 61 × 110 cm)
Courtesy of the artist and
Mor Charpentier, Paris

1. Zultanski, pp. 106–10.

W Fourier

Revolution is not progress.[1]
Atheism doesn't really
depose God.[2]
Bourgeois thought would get
along fine without the one God.
Can we, in short,
rewire the world?
The philosophers have only
interpreted the world. The point,
however, is to change it.
The internet really does turn out
to be iridescent in that so much of
it is porn, the contemporary mark
of iridescent plenitude.
 Iridescence entails
 hypercommunication; it is not
 an excluding but an exceeding
 or overloading.
 Libidinal affects arc across pure
 surfaces without depth.
 For there to be politics requires
 some structure of belief.
 God is the principle of
 submission.
 It is not that God is dead;
 it is that *media is dead*.

 Obedience is dead.

The Real is that which the spectacle claims to call into being

God has been abolished but the pillars which supported him still rise towards an empty sky.

but which is actually indifferent to it. It is

Ideas improve. The meaning of words plays a role in that improvement. Progress is necessary. Progress implies it. Plagiarism implies it. It sticks close to an author's phrasing, exploits his expressions, deletes a false idea, replaces it with the right one.

Détournement is an appropriation of past into present, an Irenic arc of excess, to be trimmed only as the exigencies of the present situation and its struggles demand.

Philosophy and war are the secular arms of the purism of transcendence.

Death stares at our
passions and we
mute them; we mesh
our desires with what
is inimical to life.

not that God is dead; it is that

media is dead. Always historicize!

Capitalism is a communicable disease in the form of a disease of communication.

Heretics are rebels
without a cause.
What are we rebelling against?

What have you got?
For there to be connections
there have to be
disconnections—
excommunication.

For there to be
politics requires
some structure
of belief.

82

Joel Sternfeld

2005

Dacha/Staff Building, Gesundheit!
Institute, Hillsboro, West Virginia,
April 2004, 1982-2005
Chromogenic print
26½ × 33¼ in. (67.3 × 84.5 cm);
framed: 29¼ × 36 in. (74.3 × 91.4 cm)
Courtesy of the artist and
Luhring Augustine, New York

Dacha / Staff Building, Gesundheit! Institute, Hillsboro, West Virginia, April 2004.

When Dr. Patch Adams envisions the forty-bed rural community health care facility that he refers to as "the free silly hospital," he hopes it will be "funny looking, full of surprises and magic."

Adams' desire to humanize healthcare has always taken radical form. From 1971 to 1983, he and nineteen other adults and their children moved into a six-bedroom home and called themselves a hospital. Three of the adults were physicians. They were continuously open to patients and saw fifteen thousand people over a period of twelve years. Initial doctor/patient interviews were three to four hours long, "so that we could fall in love with each other." Since no donations were received, nor was there any outside funding, the staff eventually left and the hospital closed.

This led Adams to his present period of fundraising, which he often does in the guise of a clown. A three-hundred-acre farm has been purchased in West Virginia—chosen because it is the most medically under-served state in the nation—and two buildings have been constructed. The Dacha / Staff Building was designed by the Yestermorrow Design / Build School of Warren, Vermont.

Amongst numerous other unconventional practices, the hospital will not charge for its services and neither will it carry malpractice insurance. Healing arts such as acupuncture, massage, yoga, herbalism and faith healing will be integrated into patient care. Patients and staff will stay at the hospital, and forty beds will be available for "plumbers, string quartets and anyone wanting a service-oriented vacation," reflecting Adams' vision that the health of the individual cannot be separated from the health of the community. Although the free silly hospital is not yet built, the idea of it can and does influence the dialogue on health care delivery systems.

83

1. Löwy, p. 22. 2. All subsequent quotations Wark, "Furious Media."

X Marx

To be modern is to be part of a universe in which, as Marx said,

"ALL THAT IS SOLID MELTS INTO AIR." [1]

Everything
is pregnant
with
its contrary.

The atmosphere in which we live weighs upon everyone with a 20,000-pound force, but do you feel it?

Some would "get rid of modern arts, in order to get rid of modern conflicts."

Every
table and
in
a chair
bourgeois
interior
resembled a
monument.

When a creative spirit like John Cage accepted the support of the Shah of Iran, and performed modernist spectacles a few miles from where political prisoners shrieked and died, the failure of moral imagination was not his alone.

A great modernist, the Mexican poet and critic Octavio Paz, has lamented that modernity is "cut off from the past and continually hurtling forward at such a dizzy pace that it cannot take root, that it merely survives from one day to the next: it is unable to return to its beginnings and thus recover its powers of renewal."

Remembering the modernisms of the nineteenth century can give us the vision and courage to create the modernisms of the twenty-first. This act of remembering can help us bring modernism back to its roots, so that it can nourish and renew itself, to confront the adventures and dangers that lie ahead.

Do we really need a modernist Marx, a kindred spirit of Eliot and Kafka and Schoenberg and Gertrude Stein and Artaud? I think we do.

Marx does not dwell much on particular inventions and innovations in their own right (in the tradition that runs from Saint-Simon through McLuhan); what stirs him is the active and generative process through which one thing leads to another, dreams metamorphose into blueprints and fantasies into balance sheets, the wildest and most extravagant ideas get acted on and acted out ("whole populations conjured out of the ground") and ignite and nourish new forms of life and action.

To appropriate the modernities of yesterday can at once be a critique of the modernities of today.

Milena Bonilla

Stone Deaf
Graphite on paper, HD video 5-minute loop, rubbing
2009-10 63 × 39⅜ in. (160 × 100 cm)
Kadist, San Francisco

Y Photography

> Those who are ignorant in matters
> of photography will be the illiterates
> of tomorrow[1]
> —Moholy-Nagy

There is no everyday activity which does not aspire to be photographed, filmed, videotaped. For there is a general desire to be endlessly remembered and endlessly repeatable. All events are nowadays aimed at the television screen, the cinema screen, the photograph, in order to be translated into a state of things.

The camera is programmed to produce photographs, and every photograph is a realization of one of the possibilities contained within the program of the camera. The number of such possibilities is large, but it is nevertheless finite: It is the sum of all those photographs that can be taken by a camera.

As long as the photograph is not yet electromagnetic, it remains the first of all post-industrial objects. Even though the last vestiges of materiality are attached to photographs, their value does not lie in the thing but in the information on their surface. This is what characterizes the post-industrial: The information, and not the thing, is valuable.

There is no such thing as naïve, non-conceptual photography. A photograph is an image of concepts. In this sense, all photographers' criteria are contained within the camera's program. . . . The imagination of the camera is greater than that of every single photographer and that of all photographers put together: This is precisely the challenge to the photographer.

Cameras are purchased by people who were programmed into this purchase by the apparatus of advertising. . . . The photographic industry learns automatically from the actions of those taking snaps (and from the professional press that constantly supplies it with test results). This is the essence of post-industrial progress. Apparatuses improve by means of social feedback.

Amateur photographers' clubs are places where one gets high on the structural complexities of cameras, where one goes on a photograph-trip—post-industrial opium dens.

A journey to Italy documented like this stores the times and places at which the person taking snaps was induced to press the button, and shows which places the camera has been to and what it did there.

Tim Lee

2008

Untitled (Alexander Rodchenko, 1928)
Four black-and-white photographs
30 × 30 in. (76.2 × 76.2 cm) each
Kadist, San Francisco

the surface.

The significance of images is on

The camera is not a tool but a plaything, and a photographer is not a worker but a player.

of images, even if their inventor may not have been aware of this; the photograph,

Texts were invented in the second millennium bc in order to take the magic out

the first technical image, was invented in the nineteenth century in order to put

texts back under a magic spell, even if its inventors may not have been aware of this.

With photography, "post-history" begins
as a struggle against textolatry.

Images . . . are metacodes of texts which,
as is yet to be shown, signify texts, not the
world out there.

The photograph is an immobile
and silent surface patiently
waiting to be distributed by means
of reproduction.

1. All quotations Flusser, p. 90.

Z The Doll, The Automaton

The seated pose of this little
girl and its circumstances
were quite normal.

How can one in fact describe,
without depreciating its value, the
physical posture of a little seated girl
while she is "dreaming?"

Expression with
its pleasure component
is a displaced pain and
a deliverance.[1]

If we can say that the clenched fist opposes the tooth, we would then be compelled to say that the image of the tooth is displaced onto the hand, the image of the sex onto the armpit, that of the leg onto the arm, that of the nose onto the heel. Hand and tooth, armpit and sex, heel and nose, in short: virtual excitation and real excitation are confused through superimposition.

[Would] the pleasure felt by the arm in pretending to be the leg . . . not be equaled by the leg's pleasure at playing the role of the arm [?]

Note: The familiar movement of swelling the chest and hollowing out the back to emphasize the breasts is naturally accompanied by an analogous movement on the lower half of the torso, which becomes emphasized as a counterweight and is, if we can put it this way, the lower breasts.

Place an unframed mirror perpendicular to a photo of a naked body and slowly turn it or move it forward while maintaining a 90° angle, in such a way that the symmetrical halves of the entire visible area gradually shrink or expand in an even fashion. The image, ceaselessly created in bubbles of elasticized skin, emerges by swelling from the somewhat theoretical fissure of the axis of symmetry.

EIN LEDERGURT TRUG REDEL NIE
(Redel never wore a leather belt)
—Anonymous

To "create thought in the mouth."

Markus Schinwald

2016

Untitled (Machine I)
Brass, wood, motor
98⅜ × 55⅛ × 23⅝ in.
(250 × 140 × 60 cm)
Gallery Thaddaeus Ropac, Paris

L'AME DES UNS JAMAIS N'USE DE MAL
(The soul of some are never worn away by evil)
—Victor Hugo

A certain category of children . . .
to talk backward: "Uoy era diputs."

the power to see with one's hand

89

OPPOSITION IS NECESSARY IN ORDER
FOR THINGS TO EXIST AND TO FORM
A THIRD REALITY.

like warm glue sucked into an irresistible void

LÉON ÉMIR CORNU D'UN ROC RIME NOËL
(Leon emir horned with a rock r a horn rhymes Christmas)
—Charles Cros

sex-armpit

1. All quotations Bellmer, p. 6.

a Social Movement

In July 2012, Facebook invited so-called ethical hackers to attack its network, and announced "banner blind" payment for them finding security holes. In 2010 Mark Zuckerberg told . . . a *New Yorker* reporter, that Facebook was blue because of his color blindness.

BuddyPress, Facebook designing your online identity is like IKEA designing Crabgrass, Ghostery your apartment. The only individuality lies in the family pictures Cryptocat, standing in your BILLY shelves. The Facebook Colour Cyn.in, Augmented Freedom Changer . . . makes it Elgg, If the users don't control the program, then it's the program that possible to easily change Identi.ca, controls the users, because it does what it does and the users are and save the color scheme Jappix, stuck with it. to the user's tastes. Kune, Pinax, Unfriend Finder Facebook's statement on its homepage is deliberately Briar, ENEMYGRAPH[1] deceptive: "It's free and always will be." Diaspora, Friendika, Secureshare, and The entanglement of social media activism with the global occupy Lorea[4] movement creates the conditions for . . . becoming a machinic cockroach. Or take the story of Amira Yahyaoui, a cyber activist from Tunisia living in exile in France. The desire to prevent her blog from being clicktivism blocked in Tunisia (internet censorship was heavy there from the beginning of the revolts) prompted her to basically change the URL of her blog on an almost daily basis. From "delle3a" it became "delle3b" and then "delle4a," and so on, with Amira giving a tip in code the previous night of what the new URL would be. The global occupy protest movement is proliferating by "contagion, epidemics, battlefields, and catastrophes." OCCUPY MOVEMENTS SPREAD LIKE CONTAGION FROM ONE URBAN CONTEXT TO THE NEXT, FROM ONE SOCIAL MEDIUM TO ANOTHER.[2]

The social web as something that actually Widespread skepticism about Anti-Social Media stops people from real actions. "Facebook and Twitter Revolutions" in North Africa You would never see a headline in the mainstream media If Web 2.0 is about connecting people' that reads: "Eighty Activists Meet Downtown to Address real identities together and bridging a Facebook Post." the ideology of horizontalism offline networks with online lives, the INTEROCCUPY the option of remaining anonymous is essential for those who are mobilizin on the margins of legality.[3]

Adam Pendleton Black Lives Matter #2 (wall work)
 Vinyl
 2015 Dimensions variable
 Courtesy of the artist, New York

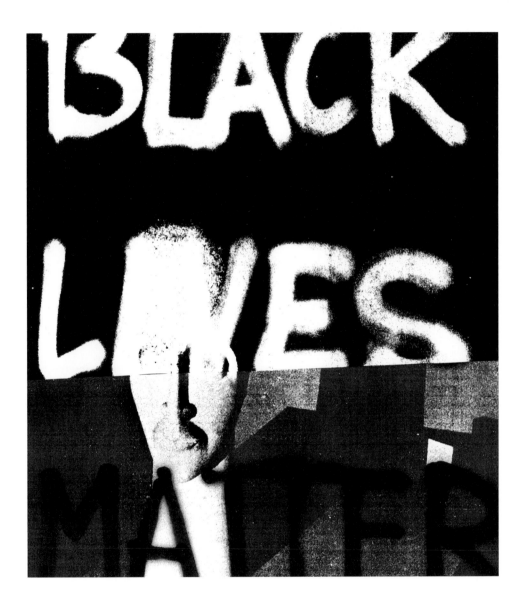

1. All Stumpel. 2. All Hatzopoulos and Kambouri.
3. All Terranova and Donovan. 4. Cabello, Franco,
and Haché, p. 340.

b Daumier

Paul and Linda McCartney's film *Daumier's Law* premiered at the Cannes Film Festival in May 1992. It was a 15-minute animated short directed by Geoff Dunbar. The film re-creates the drawings of French artist Honoré Daumier. Paul wrote and produced the film's musical score, and he performed most of it himself, recording it during late Dec. 1989. The film had been given a private London screening the preceding month.[1]

For too long Honoré Daumier has been an unsung hero, a clear but usually overlooked influence over artists such as Van Gogh, Toulouse-Lautrec and Picasso. *Daumier's Law* will ensure that his work finally receives the attention it so clearly merits.[2]

Linda was the first to be enthused by Daumier—back in her school days.

"As an art history major, both at Vermont College and the University of Arizona, I saw, supposedly, every great visual,"

she explains.

"I went through all periods of different painters and along the way there were several that really grabbed me—Daumier being one of them. He was very satirical about the different classes and fantastic at capturing people's characters."

Around this same time Linda was experiencing a re-discovery of her college interest in Daumier, and the two projects—the art and the music—suddenly came together. "I went through every drawing he ever did and really got involved," Linda says. "I got every book on Daumier and read all about his life and thought that it would be incredible to do a visual thing for Paul's music. Daumier worked for a newspaper as a satirical cartoonist, as well as being an amazing painter, and went to prison a few times for his Art. A lot of his work was about injustice and it's a theme that is so right for our times, still."

"I did about 20 minutes of music," adds Paul, "then Linda and I were looking at some Daumier drawings and getting very into him, so we hooked up the idea of injustice with my music pieces, came up with the basis for the film and got in touch with Geoff."

```
Walker Evans              Subway Portrait
                          Gelatin silver print
       1938-41            5 × 7⅞ in. (12.7 × 18.7 cm)

                          Subway Passengers, New York City: Woman
                          in Velvet Collar with Arm around Child
                          Gelatin silver print
   May 5-8, 1938          4⅝ × 6½ in. (11.7 × 16.5 cm)
                          Fisher Collection, San Francisco
```

"Paul did six pieces of music and they each had a title—Right, Wrong, Justice, Punishment, Payment and Release. He was inspired. And then we pored through the works of the great man, got everything that was available and structured the story from the material. And where we had to link it we invented 'in the style of.' We've hung the story on one character, a man from one drawing by Daumier. It's rather ambiguous because in the drawing you can't see his face but the figure is there, and we made him this Average Guy, an Everyman."

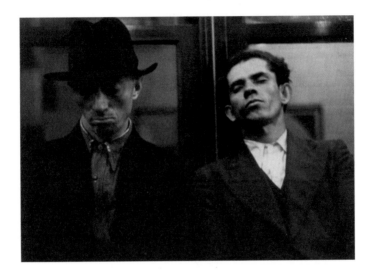

The injustice theme of *Daumier's Law* is skillfully put across during the 15 minute film, with our Mr. Average wrongfully accused, wrongfully arrested, wrongfully convicted in a particularly powerful courtroom sequence (Act 3: Justice), cruelly punished, forced to pay dues and then, at last, expelled by the tyrannical system, free to re-discover artistic beauty in his midst.

"It's all topical stuff," comments Dunbar.

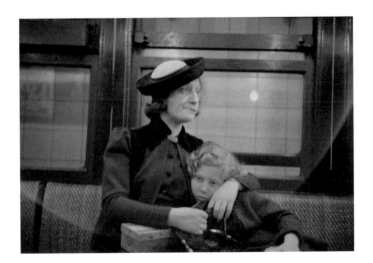

93

d Literary History, Hugo

On Victor Hugo: "He was . . . the poet not of his own sufferings . . . but of the passions of those around him. The mournful voices of the victims of the Terror . . . made their way into the *Odes*. Then the trumpet blasts of the Napoleonic victories resounded in other odes. . . . Later on, he felt obliged to let the tragic cry of militant democracy pass through him. And what is *La Légende des siècles* . . . if not the echo of the great turmoil of human history? . . . It often seems as though he had collected the sighs of all families in his domestic verse, the breath of all lovers in his love poems. . . . It is for this reason that, . . . thanks to some mysterious quality in him that is always collective and general, Victor Hugo's poetry possesses an epic character."[1]

1. "On My Own"
 There are lots of great unrequited love songs. But this is probably the best.
2. "I Dreamed a Dream"
 That "beeeee"—you know the one, right before "so different from this hell I'm living." Put that "beeeee" in a songwriting museum.
3. "One Day More"
 Don't pretend like you [don't] derive enormous satisfaction from doing the different voices for the different characters.
4. "Confrontation"
 What, you don't like watching celebrities sing to each other in blustery British accents?
5. "Do You Hear the People Sing?"
 If this song had been written in time for the actual historical barricades, then the Paris Uprising would have succeeded, and we wouldn't need the sad half of this musical.
6. "Who Am I?"
 "24601!" But especially the sustained "ooooooone!" Goosebumps.
7. "Empty Chairs at Empty Tables"
 My friennnnds, my frieeeeeeeeeeeeeeends! Don't ask me why I am crying, it is just embarrassing at this point.
8. "At the End of the Day"
 Most of the expository songs can drag, but this one is good and angry. It is also easy to work into everyday conversation.
9. "Stars"
 Javert works as a villain because he's not just some evil schmuck— he really believes he's doing God's work. "And if you fall as Lucifer fell! You fall in flame!" So stirring.
10. "A Heart Full of Love"
 "Heee was never mine to lose."—Top three most heartbreaking moments of this entire musical.[2]

```
Erica Baum              Corpse

                        Venice
                        From the Dog Ear series
                        Archival pigment prints, editions of 6
                        and 2 APs
        2014            9 × 9 in. (22.9 × 22.9 cm) each
                        Bureau, New York
```

g The Stock Exchange, Economic History

In the early light of a May dawn this is what the living room of my apartment looks like: Over the white marble and granite gas-log fireplace hangs an original David Onica. It's a six-foot-by-four-foot portrait of a naked woman, mostly done in muted grays and olives, sitting on a chaise longue watching MTV, the backdrop a Martian landscape, a gleaming mauve desert scattered with dead, gutted fish, smashed plates rising like a sun

96

burst above the woman's yellow head, and the whole thing is framed in black aluminum steel. The painting overlooks a long white down-filled sofa and a thirty-inch digital TV set from Toshiba; it's a high-contrast highly defined model plus it has a four-corner video stand with a high-tech tube combination from NEC with a picture-in-picture digital effects system (plus freeze-frame); the audio includes built-in MTS and a five-watt-per-channel on-board amp. A Toshiba VCR sits in a glass

case beneath the TV set; it's a super-high-band Beta unit and has built-in editing function including a character generator with eight-page memory, a high-band record and playback, and three-week, eight-event timer. A hurricane halogen lamp is placed in each corner of the living room. Thin white venetian blinds cover all eight floor-to-ceiling windows. A glass-top coffee table with oak legs by Turchin sits in front of the sofa, with Steuben glass animals placed strategically

around expensive crystal ashtrays from Fortunoff, though I don't smoke. Next to the Wurlitzer jukebox is a black ebony Baldwin concert grand piano. A polished white oak floor runs throughout the apartment. On the other side of the room, next to a desk and a magazine rack by Gio Ponti, is a complete stereo system (CD player, tape deck, tuner, amplifier) by Sansui with six-foot Duntech Sovereign 2001 speakers in Brazilian rosewood. A down-filled futon lies on an oakwood frame in the

center of the bedroom. Against the wall is a Panasonic thirty-one-inch set with a direct-view screen and stereo sound and beneath it in a glass case is a Toshiba VCR. I'm not sure if the time on the Sony digital alarm clock is correct so I have to sit up then look down at the time flashing on and off on the VCR, then pick up the Ettore Sottsass push-button phone that rests on the steel and glass nightstand next to the bed and dial the time number. A cream leather, steel and wood

chair designed by Eric Marcus is in one corner of the room, a molded plywood chair in the other. A black-dotted beige and white Maud Sienna carpet covers most of the floor. One wall is hidden by four chests of immense bleached mahogany drawers. In bed I'm wearing Ralph Lauren silk pajamas and when I get up I slip on a paisley ancient madder robe and walk to the bathroom. I urinate while trying to make out the puffiness of my reflection in the glass that encases a baseball poster

hung abov toilet. Aft I change i Ralph Lau monogram boxer sho and a Fair sweater ar slide into polka-dot Enrico Hi slippers I a plastic ic pack arou my face an commenc with the m ing's stretc exercises. Afterward I stand in of a chron and acryli Washmob bathroom sink—wit soap dish, holder, an railings th serve as to bars, whic I bought a Hastings to use whi the marble sinks I ord from Finla

Andreas Gursky

1997

Chicago Mercantile Exchange
Chromogenic print
73¼ × 98⅜ in. (186 × 250 cm)
Colleción Isabel y Agustín
Coppel (CIAC), Mexico City

eing
ed—and
at my
ction with
e pack
n. I pour
Plax
aque
ula into a
ess-steel
ler
wish it
nd my
h for
sec-
Then I
eze Rem-
dt onto a
tortoise-
tooth-
and
brushing
eeth (too
over to
prop-
—
maybe
sed
e bed
ight?)
inse with
rine. Then
ect my
s and use
brush.
e the
ack mask

off and use
a deep-pore
cleanser lotion,
then an herb-
mint facial
masque which

Interplak tooth
polisher (this
in addition
to the tooth-
brush) which
has a speed

sage the gums
while the short
ones scrub the
tooth surfaces.
I rinse again,
with Cepacol.

shower head
that adjusts
within a
thirty-inch
vertical range.
It's made from

water-activated
gel cleanser,
then a hon-
ey-almond
body scrub,
and on the face

ration, salts,
oils, airborne
pollutants and
dirt that can
weigh down
hair and flatten
it to the scalp
which can
make you
look older.
The con-
ditioner is
also good—
silicone
technology
permits
condition-
ing benefits
without
weighing
down the
hair which
can also
make you
look older.
On week-
ends or
before a
date I prefer
to use the
Greune Natu-
ral Revitalizing
Shampoo.[1]

97

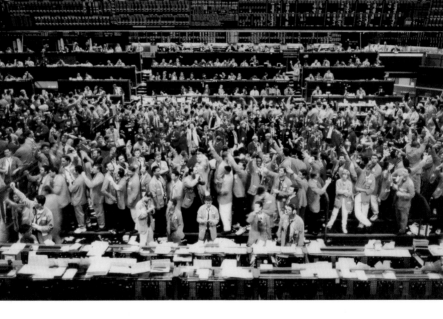

I leave on for
ten minutes
while I check
my toenails.
Then I use
the Probright
tooth polisher
and next the

of 4200 rpm
and reverses
direction
forty-six times
per second;
the larger tufts
clean between
teeth and mas-

I wash the
facial mas-
sage off with
a spearmint
face scrub.
The shower
has a universal
all-directional

Australian
gold-black
brass and
covered with a
white enamel
finish. In
the shower
I use first a

an exfoliating
gel scrub.
Vidal Sassoon
shampoo is
especially good
at getting rid of
the coating of
dried perspi-

1. Ellis, pp. 24–29.

i Reproduction Technology, Lithography

I am sitting in a room different from the one you are in now. I am recording the sound of my speaking voice and I am going to play it back into the room again and again until the resonant frequencies of the room reinforce themselves so that any semblance of my speech, with perhaps the exception of rhythm, is destroyed. What you will hear, then, are the natural resonant frequencies of the room articulated by speech. I regard this activity not so much as a demonstration of a physical fact, but more as a way to smooth out any irregularities my speech might have.[1]

Jesus' blood never failed me yet.[4] I had to, like, open the bruise up, and let *some of the bruise*

But time has slowly killed these loops and the pastoral (and ambient) ideals they once represented. What we hear on The Disintegration Loops are not poetic images of nature or beauty but nature and beauty as they truly exist in this world: always fleeting, slowly dying. What makes these works so memorable is not the fact that the loops are slowly disintegrating but the fact that we get to hear their deaths. In a very real way, we experience the muddled, ugly, brutal realities of life. What's more, these muddled, ugly, brutal realities of life are, in their own way, incredibly beautiful, perhaps more beautiful than the original, pristine loops ever could have been.[2]

Jesus' blood never failed me yet.[4] I had to, like, open the bruise up, and let *some*

Not only the characteristic movements of the different actions, but even those slight and scarce definable peculiarities which distinguish the movements from one athlete to another in performing the same feat, of one horse from another in moving at the same gait, and so forth, are perfectly recognisable in the combination of pictures which, separately seen, simply startle us by the new light which they throw on the real nature of these rapid motions.[5]

of the bruise blood come out to show them.[3]

98

Timm Ulrichs

Walter Benjamin: "The Work of Art in the Age of Mechanical Reproduction"– Interpretation: Timm Ulrichs, The Photocopy of the Photocopy of the Photocopy of the Photocopy"
Sequence of 100 black-and-white photocopies, wooden frames

1967

11¾ × 8¼ in. (29.7 × 21 cm) each
Courtesy of the artist and Wentrup, Berlin

1. Lucier. 2. [Heumann]. 3. Daniel Hamm in Reich.
4. Bryars. 5. Muybridge, p. 6.

k The Commune

When the arts
flourished in the old
days it was sufficient for an art-
ist to have a rich patron and then to devel-
op under the protection of his important sponsor. All
nobles had their pet artists. . . . Today, for the most part, this The World
method of developing and protecting art has passed Power Alliance was de-
out of existence and I am wondering if the signed to bring the World's minds
WPA art projects may not take together . . . This programming is stagnating
their place.[1] the minds of the people, building a wall between races.
This wall must be destroyed, and it will fall. By using the untapped
energy potential of sound, the WPA will smash this wall much the
same as certain frequencies shatter glass. Brothers of the under-
ground transmit your tones and frequencies from all locations of
this world. Wreak havoc on the programmers! . . . Disappearance
is our future.[5]

Andrea Bowers The Triumph of Labor
 Marker on cardboard
2016 108¾ × 248 × 6½ in.
 (276.2 × 629.5 × 16.5 cm)
 Rennie Collection, Vancouver, British
 Columbia, courtesy of Susanne
 Vielmetter, Los Angeles Projects

Republican
George Dondero,
who persistently
branded modern
art the result
of a communist
conspiracy.[2]
The Grand Canyon
of industrial murals
resides in Detroit:
Diego Rivera's depiction
of a Ford auto
assembly
plant.[3]

We move
on to the bleak
adversity of the 1930s, un-
employment lines, home relief, the
WPA (whose splendid monument, the Bronx
County Courthouse, stands just above the Yankee Stadium),
radical passions and energies exploding, street-corner fights be-
tween Trotskyites and Stalinists, candy stores and cafeterias ablaze
with talk all through the night; then to the excitement and anxiety
of the postwar years, new affluence, neighborhoods more vibrant
than ever, even as new worlds beyond the neighborhoods begin
to open up, people buy cars, start to move; to the Bronx's new
immigrants from Puerto Rico, South Carolina, Trinidad, new
shades of skin and clothes on the street, new music and rhythms,
new tensions and intensities; and finally, to Robert Moses and his
dread road, smashing through the Bronx's inner life, transforming
evolution into devolution, entropy into catastrophe, and creating
the ruin on which this work of art is built.[6]

Erwin S. Barrie,
the director
of this artists'
cooperative
gallery, reported
that fewer than
10 percent of his
customers were
interested in
"so-called
modern art,
and 90 percent
despise it."[4]

1. Eleanor Roosevelt in Ross, p. 303. 2. Decherney, p. 166.
3. Kelley, p. 7. 4. Marquis, p. 241. 5. Eshun, p. 122. 6. Berman, p. 342.

1 The Seine, The Oldest Paris

April is the favourite month for young female suicid[e], nine months after summer. Whereas hanging was the favoured me[thod of] suicide for males. Unrequited love, unwanted pregnancy, by females. Unrequited love, unwanted pregnancy, by a smile so relaxed and at ease … that one could have believed that she drowned in an instant of extreme happiness."[11]

L'Inconnue de la Seine, described by Blanchot as "a young girl with closed eyes, c[…]

Sometimes the wounds on the corpse could have been caused by the body bumping against the piers of a Seine bridge … dredged from water, sometimes revived.

Tagged on the Saint-Michel bridge in 1961: "Ici on noie les Algériens." ("Here we drown Algerians").

When the Seine was full of bodies.[1]

It is possible to match the very hot summers and the very cold winters … that persuaded Parisians, e[…]

children, to go swimming and skating—with the tragic consequences of their enthusiasms.[9]

Algerians were thrown into and drowned in the Seine.[2]

"Sales Juifs! À la Seine! Mort aux fellaghas!" ("Dirty Jews! Into the Seine! Death to the [Algerian] rebels!")[2]

Already at this time, policemen [were] boasting about throwing Algerians in the Seine river.[3]

Prefecture of Police, very close to Notre Dame de Paris.[4]

It was a list of death, a catalogue of corpses. … What I wanted to do was to attempt some sort of resurrection of those people dredged dripping from the Seine.[8]

Dozens of bodies were later pull[ed]

La Seine était rouge (Paris, octobre 1961)[6]

at the Saint-Michel bridge in the center of Paris and near the[…]

numerous CPR courses. Therefore, the face has been called by some "the most kissed face" of all time.[12]

Aid mannequin Resusci Anne … and was used for the head of the First Aid mannequin Resusci Anne … used starting in 1960 in numerous CPR courses.

The face of the unknown woman was used for the head of the First

Haris Epaminonda and
Daniel Gustav Cramer

Untitled #13 t/c
Framed found page
11 × 8½ in. (27.9 × 21.7 cm)
Courtesy of the artists and
Casey Kaplan Gallery, New York

2010

1. Sadek. 2. "Paris Massacre of 1961." 3. Einaudi and Rajsfus, pp. 73–74.
4. "Paris Massacre of 1961." 5. Woods, p. 256. 6. Sebbar. 7. "Paris Massacre of 1961."
8. Woods, p. 256. 9. Woods, p. 256. 10. Woods, p. 256. 11. "L'Inconnue de la Seine."
12. "L'Inconnue de la Seine."

m Idleness

Workers of the world . . .

relax!

Liberals say we should end
employment discrimination.
I say we should end employment.

We all need a lot more time for sheer sloth and slack than we ever enjoy now.

All the old ideologies are conservative because they believe in work. and in the frenzied but hopeless attempt to forget about work.

No one should ever work.[1]

Work is the source of nearly all the misery in the world.

In order to stop suffering, we have to stop working.

A new way of life based on play.

I favor full *un*employment.

I agitate for permanent revelry.

I support the right to be lazy.

The alternative to work isn't just idleness.

To be ludic is not to be ludicrous.

To be ludic is not to be quaaludic.

I treasure the pleasure of torpor.

Leisure is nonwork for the sake of work.

A system of permanent revelry.

We ought to take frivolity seriously.

Work makes a mockery of freedom.

Leisure is the time spent recovering from work and in the frenzied but hopeless attempt to forget about work.

Pierre Huyghe

Sleeptalking (after "Sleep," 1963, by Andy Warhol, Accompanied by the Voice of John Giorno)
Stills from a projection of super 16mm black-and-white film, transferred to video, sound, edition of 4

1998
Running time: film 30 min., soundtrack 64 min.
Marian Goodman Gallery, New York

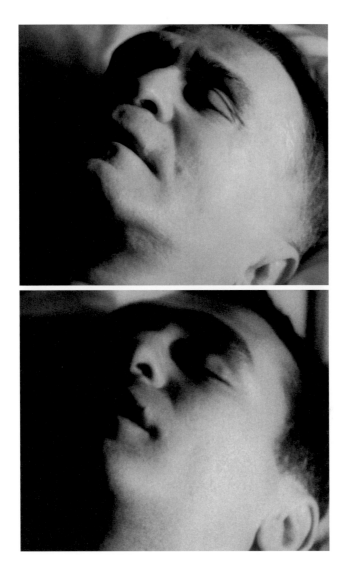

105

p ## Anthropological Materialism, History of Sects

I DON'T KNOW WHAT IT IS,
BUT I KNOW IT WHEN I SEE IT.[1]

For many years, we have all been living in the realm of Prince Mangogul: under the spell of an immense curiosity about sex, bent on questioning it, with an insatiable desire to hear it speak and be spoken about, quick to invent all sorts of magical rings that might force it to abandon its discretion.[2]

Both Diderot's fable and the hard-core film *The Opening of Misty Beethoven*, for example, share the goal of figuring and measuring the "truth" of sex with the particular magic at their disposal; yet to each this truth is a very different thing. . . . Where Diderot's genie conjures up the magic silver ring that renders the prince invisible and forces the women to confess their pleasures unaware of his presence, the wizardry of cinematic representation provides its spectators with a seemingly perfected form of invisibility.[3]

Diderot:
"For me, my thoughts are my prostitutes."[4]

Magritte's "The Indiscreet Jewels (*Les bijoux indiscrets*)," (1963) and Diderot's "Ceci n'est pas un conte" (1772) . . . [are] fully recuperated in a dialectic which assimilates the negative by affirming the resemblance of the copy to its privileged model.[6]

There are two pipes. Or rather must we not say, two drawings of the same pipe? Or yet a pipe and the drawing of that pipe, or yet again two drawings each representing a different pipe? Or two drawings, one representing a pipe and the other not, or two more drawings yet, of which neither the one nor the other are or represent pipes? Or yet again, a drawing representing not a pipe at all but another drawing, itself representing a pipe so well that I must ask myself: To what does the sentence written in the painting relate?[7]

Boccaccio: the first work of modern pornography.[5]

Where alchemy, through spiritual Double of an tions only on the level of real matter, the theater must also be considered as the Double, not of this direct, everyday reality of which it is gradually being reduced to a mere inert replica—as empty as it is sugarcoated—but of another archetypal and dangerous reality, a reality of which the Principles, like dolphins, once they have shown their heads, hurry to dive back into the obscurity of the deep.[8]

Ry Rocklen

2015

Blue Eyed Worshipper,
Southern Mesopotamia, 2600-2500 BC
Ceramic vessels, mirror-mounted panel,
brass, glass
52½ × 32¾ × 9½ in.
(133.4 × 83.2 × 24.1 cm)
Bjørnholt Collection, Oslo

1. Supreme Court Justice Potter Stewart, 1954, in Williams, p. 5.
2. Foucault, *The History of Sexuality*, p. 77. 3. Williams, p. 31–32.
4. Diderot. 5. Hyde, p. 65. 6. Pucci, p. 1. 7. Foucault, *This Is Not a Pipe*,
p. 16. 8. Artaud, p. 48.

r École Polytechnique

The City Council forced [Loos] to add flowerboxes to the mute, square windows of Looshaus in the Michaelerplatz; his Café Museum in Elisabethstrasse was instantly dubbed the Café Nihilismus by architects who later imitated it. It wasn't the absence of the past that gave Loos's buildings their startling appearance, but the absence of pointless decoration.[3]

His buildings taunted the outside world with casually wrought secrecy. Inside, elaborate geometries of ovoids, squared arches, trapezoidal perspectives articulated in parquet patterns, marble and mahogany facings, depths protracted by mirrored walls, space construed to anticipate the imprint of organic patterns, rationalized to absorb the overrun of daily jumble and successive generations of furniture.[4]

First, in his corrosive contempt for superficial ornament, Loos advanced not only the cause of abstraction fundamental to modernist art and architecture, but also the critique of kitsch crucial to modernist criticism. Second, in lieu of kitschy ornament, he elevated certain objects of everyday use as stylistic models of design, in a manner also adopted by many other modernists. Loos chose objects somewhere between handicraft and industry, such as tailored clothes, shoes, luggage, saddles, Thonet chairs, and wine bottles.[5]

The extraordinary essays Loos published between 1897 and 1900 rail against "retro" styling in underclothes, furniture, glassware and hats, celebrate the plumbing and silversmith trades, survey the history of building materials and explain the evolution of footwear. Loos took a thoughtful interest in everything from counterfeit pleats in the Norfolk jacket to the suspension springs of English mail coaches. He decries the unnecessary, the superannuated, the dysfunctionally "beautiful," pinning the false in cultural artifacts to a deep falsity in the culture's premises.[6]

They

building should be dumb on the outside and reveal its wealth only on the inside.[2]

108

The world Loos envisioned, of course, has not and could not come about. For its emergence would demand the excision of that signal part of the human persona that expresses itself in the ornament against which Loos contended, or in the grotesque and in caricature.[7]

But maybe times have changed again; maybe we are in a moment when distinctions between practices might be reclaimed or remade—without the ideological baggage of purity and propriety attached.[8]

109

The evolution of culture is synonymous with the removal of ornament from utilitarian objects.[1]

1. Loos, p. 20. 2. Indiana, p. 144. 3. Indiana, p. 144.
4. Indiana, p. 144. 5. Foster, *Prosthetic Gods*, p. 57.
6. Indiana, p. 143. 7. Kelley, pp. 25–26. 8. Foster, *Design and Crime*, p. 14.

Walter Benjamin, c. 1925,
photographed by Germaine Krull

Text Sources

Apollinaire, Guillaume. "Simultanéités." In *Calligrammes: Poems of Peace and War (1913–1916)*, translated by Anne Hyde Greet, 284–87. Berkeley: University of California Press, 1980.

Artaud, Antonin. *The Theater and Its Double*. Translated by Mary Caroline Richards. Evergreen Original E-127. New York: Grove Press, 1958.

Ashbery, John. *Self-Portrait in a Convex Mirror: Poems*. New York: Viking Press, 1975.

Austen, Jane. *Lady Susan—The Watsons*. Jane Austen's Works 3. Boston: Little, Brown, 1903.

Badiou, Alain. *On Beckett*. Edited by Alberto Toscano and Nina Power. Dissymetries. Manchester, England: Clinamen Press, 2003.

Barthes, Roland. *The Neutral: Lecture Course at the Collège de France (1977–1978)*. Edited by Thomas Clerc under the direction of Eric Marty. Translated by Rosalind E. Krauss and Denis Hollier. European Perspectives. New York: Columbia University Press, 2005.

Baudrillard, Jean. *America*. Translated by Chris Turner. London and New York: Verso, 1989.

———. *Baudrillard Live: Selected Interviews*. Edited by Mike Gane. London: Routledge, 1993.

———. *The Vital Illusion*. Edited by Julia Witwer. Wellek Library Lectures at the University of California, Irvine. New York: Columbia University Press, 2000.

Beckett, Samuel. "Company." In *Nohow On*, 5–52. London: Calder, 1989.

———. *Malone Dies*. Evergreen Book E-39. New York: Grove Press, 1956.

———. "The Unnamable." In *Three Novels: Molloy, Malone Dies, The Unnamable*, 291–414. New York: Grove Press, 2009.

———. *Waiting for Godot: Tragicomedy in Two Acts*. New York: Grove Press, 1982.

Bellmer, Hans. "The Images of the Ego." In *Little Anatomy of the Physical Unconscious, or, the Anatomy of the Image*, translated by Jon Graham, 3–20. Waterbury Center, VT: Dominion, 2004.

Benjamin, Walter. *The Arcades Project*. Translated by Howard Eiland and Kevin McLaughlin. Cambridge, MA: Belknap Press of Harvard University Press, 2002.

———. *Charles Baudelaire: A Lyric Poet in the Era of High Capitalism*. Translated by Harry Zohn. London: NLB 1973.

Berman, Marshall. *All That Is Solid Melts Into Air: The Experience of Modernity*. New York: Penguin Books, 1982.

Black, Bob. "The Abolition of Work." *Primitivism*. http://www.primitivism.com /abolition.htm.

Bourget, Paul. Obituary notice for Victor Hugo from *Le Journal des Débats*. In *Victor Hugo devant l'opinion: Presse Française, Presse Étrangère*, 88–100. Paris: Office de la Presse, 1885.

Broodthaers, Marcel. *Catalogue des Livres, 1957–1975 / Catalogue of Books, 1957–1975 / Katalog der Bucher, 1957–1975*. Exhibition catalogue. Cologne: Galerie Michael Werner, 1982.

Bryars, Gavin. "Jesus' Blood Never Failed Me Yet." *The Sinking of the Titanic*, Obscure Records, LP, 1971.

Burroughs, William S. "The Cut-Up Method of Brion Gysin" and "Cut-Up of Prose Poem 'Stalin' by Sinclair Beiles." In William S. Burroughs and Brion Gysin, *The Third Mind*, unpaginated. New York: Viking Press, 1978.

Buck-Morss, Susan. *The Dialectics of Seeing*. Cambridge, MA: MIT Press, 1989.

Cabello, Florencio, Marta G. Franco, and Alexandra Haché. "Towards a Free Federated Social Web: Lorea Takes the Networks!" In *Unlike Us Reader: Social Media Monopolies and Their Alternatives*, edited by Lovink Geert and Miriam Rasch, 338–46. INC Reader 8. Amsterdam: Institute of Network Cultures, 2013.

Cooper, Simon. *Technoculture and Critical Theory: In the Service of the Machine?* Routledge Studies in Science, Technology, and Society 5. London and New York: Routledge, 2003.

Coyne, Richard. *The Tuning of Place: Sociable Spaces and Pervasive Digital Media*. Cambridge, MA: MIT Press, 2010.

Crary, Jonathan. *24/7: Late Capitalism and the Ends of Sleep*. London: Verso, 2013.

Cure, The. "How Beautiful You Are." *Kiss Me, Kiss Me, Kiss Me*. Fiction, Elektra Records 8321302, 1987, compact disc / MC / limited LP. (Inspired by and based on Charles Baudelaire's poem "The Eyes of the Poor.")

Debord, Guy. "The Bad Old Days Will End." In *Leaving the 20th Century: The Incomplete Work of the Situationist International*, edited and translated by Christopher Gray, 33–37. London: Rebel Press, 1998.

———. "Juin 1952." Part 1 of *Mémoires: Structures portantes d'Asger Jorn*. [France]: Internationale Situationniste, 1959.

Decherney, Peter. *Hollywood and the Culture Elite: How the Movies Became American*. New York: Columbia University Press, 2005.

Derrida, Jacques. *Glas*. Translated by John P. Leavey Jr. and Richard Rand. Lincoln: University of Nebraska Press, 1986.

Desan, Philippe. *L'imaginaire économique de la Renaissance*. Littérature et Anthropologie. Mont-de-Marsan: Éditions Interuniversitaires, 1993.

Diderot, Denis. *Le neveu de Rameau*. Edited by Jean-Claude Bonnet. GF 143. Paris: Flammarion, 1983. Translated by Ian C. Johnston

as *Rameau's Nephew* (Prague: E-artnow, 2013, PDF e-book).

Dobbins, Amanda, and Margaret Lyons. "Vulture Lists: Ranking All the Songs from *Les Misérables*." *Vulture*, December 21, 2012. http://www.vulture.com/2012/12/ranking-all-the-songs-from-les-misrables.html.

Dubbini, Renzo. *Geography of the Gaze: Urban and Rural Vision in Early Modern Europe*. Translated by Lydia G. Cochrane. Chicago: University of Chicago Press, 2002.

Dworkin, Craig. *Motes*. New York: Roof Books, 2011.

———. "Zero Kerning." In "Kenneth Goldsmith and Conceptual Poetics." Special issue edited by Lori Emerson and Barbara Cole, *Open Letter* 12, no. 7 (Fall 2005): 10–20.

Einaudi, Jean-Luc, and Maurice Rajsfus. *Les Silences de la Police: 16 Juillet 1942–17 Octobre 1961*. Paris: L'Esprit Frappeur, 2001.

Egan, Jennifer. "Fiction: Black Box." *New Yorker*, June 4 and 11, 2012. http://www.newyorker.com/magazine/2012/06/04/black-box-2.

Ellis, Bret Easton. *American Psycho: A Novel*. New York: Vintage Books, 1991.

Erlmann, Veit. "But What of the Ethnographic Ear?: Anthropology, Sound, and the Senses." In *Hearing Cultures: Essays on Sound, Listening, and Modernity*, edited by Veit Erlmann, 1–20. Wenner-Gren International Series. Oxford and New York: Berg, 2004.

Eshun, Kodwo. *More Brilliant Than the Sun: Adventures in Sonic Fiction*. London: Quartet Books, 1998.

Ferrell, Jeff. "The Only Possible Adventure: Edgework and Anarchy (2004)." In *Edgework: The Sociology of Risk-Taking*. Edited by Stephen Lyng. London: Routledge, forthcoming.

Flusser, Vilém. *Towards a Philosophy of Photography*. London: Reaktion Books, 2000.

Foster, Hal. *Design and Crime: And Other Diatribes*. Radical Thinkers. London and New York: Verso, 2003.

———. *Prosthetic Gods*. Cambridge, MA, and London: MIT Press, 2004.

Foucault, Michel. *The History of Sexuality, vol. 1, An Introduction*. Translated by Robert Hurley. New York: Pantheon Books, 1978.

———. *The Politics of Truth*. Edited by Sylvère Lotringer. Translated by Lysa Hochroth and Catherine Porter. Los Angeles: Semiotext(e), 2007.

———. *This Is Not a Pipe*. Translated and edited by James Harkness. Berkeley: University of California Press, 1982.

Gardner, Colin. "Roland Barthes." In *Film, Theory and Philosophy: The Key Thinkers*, edited by Felicity Colman, 109–21. Montreal and Ithaca, NY: McGill-Queens University Press, 2009.

Gasché, Rodolphe. *The Tain of the Mirror: Derrida and the Philosophy of Reflection*. Cambridge, MA: Harvard University Press, 1986.

Gilbert and George. "The Pink Elephants." In *The Words of Gilbert and George*, 75. London: Violette Editions, 1997.

Goldsmith, Kenneth. *Capital*. New York: Verso, 2015.

———. "Epiphany." In Tony Herrington, ed., *Epiphanies: Life Changing Encounters with Music*. London: Strange Attractor Press/Wire, 2015.

———. *Wasting Time on the Internet*. New York: HarperCollins, 2016.

Graf, Alexander. "Paris–Berlin–Moscow: On the Montage Aesthetic in the City Symphony Films of the 1920s." In *Avant-Garde Film*, edited by Alexander Graf and Dietrich Scheunemann, 77–91. Avant-Garde Critical Studies 23. Amsterdam and New York: Rodopi, 2007.

Grau, Oliver. *Virtual Art: From Illusion to Immersion*. Translated by Gloria Custance. Cambridge, MA: MIT Press, 2003.

Graw, Isabelle. *High Price: Art between the Market and Celebrity Culture*. Berlin and New York: Sternberg Press, 2009.

Green, David. "Marking Time: Photography, Film and Temporalities of the Image." In *Stillness and Time: Photography and the Moving Image*, edited by David Green and Joanna Lowry, 9–21. Brighton: Photoworks/Photoforum, 2006.

Guyotat, Pierre. *Eden, Eden, Eden*. Translated by Graham Fox. London: Creation Books, 1995.

Halavais, Alexander. *Search Engine Society*. Digital Media and Society Series. Cambridge, England, and Malden, MA: Polity Press, 2009.

Harkin, James. *Niche: Why the Market No Longer Favours the Mainstream*. London: Little, Brown, 2011.

Hatzopoulos, Pavlos, and Nelli Kambouri. "The Tactics of Occupation: Becoming Cockroach." In *Unlike Us Reader: Social Media Monopolies and Their Alternatives*, edited by Lovink Geert and Miriam Rasch, 289–95. INC Reader 8. Amsterdam: Institute of Network Cultures, 2013.

Heidegger, Martin. *Basic Writings*. London: Routledge, 1993.

Herman, Daniel. "Mall: Requiem for a Type." In *Harvard Design School Guide to Shopping*, edited by Chuihua Judy Chung, Jeffrey Inaba, Rem Koolhaas, and Sze Tsung Leong, 460–75. Project on the City 2. Cologne: Taschen; Cambridge, MA: Harvard Design School, 2001.

[Heumann, Michael.] "William Basinski, The Disintegration Loops I–IV." *Haunted Ink*. http://thelibrary.hauntedink.com/reviews/basinski-disintegration.html.

Heylin, Clinton. *Bootleg: The Secret History of the Other Recording Industry*. New York: St. Martin's Press, 1994.

Holmes, David. *Communication Theory: Media, Technology and Society*. London and Thousand Oaks, CA: SAGE Publication, 2005.

Horkheimer, Max, and Theodor W. Adorno. *Dialectic of Enlightenment: Philosophical Fragments*. Edited by Gunzelin Schmid Noerr. Translated by Edmund Jephcott. Cultural Memory in the Present. Stanford, CA: Stanford University Press, 2002.

Huyssen, Andreas. *Present Pasts: Urban Palimpsests and the Politics of Memory*. Cultural Memory in the Present. Stanford, CA: Stanford University Press, 2003.

Hyde, H. Montgomery. *A History of Pornography*. London: Heinemann, 1964.

"L'Inconnue de la Seine." *Wikipedia*. Last modified June 7, 2016. https://en.wikipedia.org/wiki/L%27Inconnue_de_la_Seine.

Indiana, Gary. *Utopia's Debris: Selected Essays*. New York: Basic Books, 2008.

Jabès, Edmond. *Elya*. Paris: Gallimard, 1969. Translated by Mary Ann Caws. In *The Eye in the Text: Essays on Perception, Mannerist to Modern*. Princeton, NJ: Princeton University Press, 1981

Kelley, Mike. *Foul Perfection: Essays and Criticism*. Edited by John C. Welchman. Cambridge, MA: MIT Press, 2003.

King, Stephen. *Carrie*. New York: Knopf Doubleday, 2008.

Kishik, David. *The Manhattan Project*. Stanford, CA: Stanford University Press, 2015.

Koolhaas, Rem. "Junkspace: The Debris of Modernization." In *Harvard Design School Guide to Shopping*, edited by Chuihua Judy Chung, Jeffrey Inaba, Rem Koolhaas, and Sze Tsung Leong, 408–21. Project on the City 2. Cologne: Taschen; Cambridge, MA: Harvard Design School, 2001.

Koolhaas, Rem, Stefano Boeri, Sanford Kwinter, Nadia Tazi, and Hans Ulrich Obrist. *Mutations*. Barcelona: ACTAR; Bordeaux: Arc en Rêve Centre d'Architecture, 2000.

Kovesi, Catherine. "Brought to Heel?: A Short History of Failed Attempts to Bring Down the High-Heeled Shoe in Venice and Beyond." In "On Failure." Special issue of *Vestoj*, no. 6 (Autumn 2015): 65–70.

Lacan, Jacques. "The Mirror Stage as Formative of the Function of the *I* Function as Revealed in Psychoanalytic Experience." Delivered at the 16th International Congress of Psychoanalysis, Zurich, July 17, 1949. In *Écrits: A Selection*, translated by Alan Sheridan. London: Routledge, 2001.

———. "Aggressivity in Psychoanalysis." In *Écrits: A Selection*, translated by Alan Sheridan, 9–32. London: Routledge, 2001.

Lacour-Gayet, Robert. "La Spéculation en Amérique." *Revue de Paris* 36, no. 9 (May 1929): 158–75. Republished in English (translated by Eric Savoth) in Urs Stäheli, *Spectacular Speculation: Thrills, the Economy, and Popular Discourse* (Stanford, CA: Stanford University Press, 2013), 19.

Large, David Clay. *Berlin*. New York: Basic Books, 2000.

Leong, Sze Tsung. "Ulterior Spaces: Invisible Motives." In *Harvard Design School Guide to Shopping*, edited by Chuihua Judy Chung, Jeffrey Inaba, Rem Koolhaas, and Sze Tsung Leong, 764–92. Project on the City 2. Cologne: Taschen; Cambridge, MA: Harvard Design School, 2001.

Leslie, Esther. *Walter Benjamin: Overpowering Conformism*. Modern European Thinkers. London and Sterling, VA: Pluto Press, 2000.

Lewisohn, Mark. "In Honour of Honoré." *Club Sandwich* 62 (Summer 1992). http://www.wingspan.ru/magazines/cs/cs62/page08.html.

Lippard, Lucy R. "Scattering Selves." In *Inverted Odysseys: Claude Cahun, Maya Deren, Cindy Sherman*, edited by Shelley Rice, 27–42. Exhibition catalogue. Cambridge, MA, and London: MIT Press, 2000.

Loos, Adolf. "Ornament and Crime (1908)." In *Programs and Manifestoes on 20th-Century Architecture*, edited by Ulrich Conrads, 19–24. Cambridge, MA: MIT Press, 1971.

Löwy, Michael. "Marxism and Utopian Vision." In *On Changing the World: Essays in Political Philosophy, from Karl Marx to Walter Benjamin*, 16–22. Revolutionary Studies. Atlantic Highlands, NJ: Humanities Press, 1993.

Lucier, Alvin. *I Am Sitting in a Room*, 1969. UbuWeb. http://www.ubu.com/sound/lucier.html.

Lyotard, Jean-François. *The Inhuman: Reflections on Time*. Stanford, CA: Stanford University Press, 1991.

Mac Low, Jackson. "5th Light Poem and 2nd Piece for George Brecht to Perform tho Others May Also Unless He Doesn't Want Them To—13 June 1962." In *22 Light Poems*, 16. Los Angeles: Black Sparrow Press, 1968.

Mager, Astrid. "Mapping, Practicing and Thinking 'the InterNet': Challenging Network Thought in the Context of Online Health Information." *New Network Theory, Amsterdam, June 28–30, 2007: Collected Abstracts and Papers* (ASCA Conference), 38–51. http://www.networkcultures.org/_uploads/27.pdf.

Mallarmé, Stéphane. "Un Coup de Dés Jamais N'Abolira Le Hasard," 1897. Reprinted in *Poème: Un Coup de Dés Jamais N'Abolira Le Hasard*. Paris: La Nouvelle Revue Française, 1914.

———. *Igitur, Divagations, Un Coup de dés*. Paris: Gallimard, 1976. Translated by Mary Ann Caws. In *The Eye in the Text: Essays on Perception, Mannerist to Modern*, 129. Princeton, NJ: Princeton University Press, 1981.

Marinetti, F. T. "The Manifesto of Futurism." In *Futurism: An Anthology*, edited by Lawrence Rainey, Christine Poggi, and Laura Wittman, 51–53. New Haven: Yale University Press, 2009.

113

——. "Destruction of Syntax—Imagination without Strings—Words-in-Freedom." In Marjorie Perloff, *The Futurist Moment: Avant-Garde, Avant Guerre, and the Language of Rupture*, 57. Chicago: University of Chicago Press, 1986.

Marquis, Alice Goldfarb. *Marcel Duchamp: The Bachelor Stripped Bare; A Biography*. Boston: Museum of Fine Arts, 2002.

Marshall, Peter. *Demanding the Impossible: A History of Anarchism; Be Realistic: Demand the Impossible*. London: Harper Perennial, 2008.

——. *Guy Debord and the Situationists* (excerpt). Nothingness.org. http://library.nothingness.org/articles/SI/en/display/73.

Marx, Karl. *Grundrisse: Foundations of the Critique of Political Economy*. Translated by Martin Nicolaus. The Pelican Marx Library. London: Penguin / New Left Review, 1973.

"May 1968 Graffiti." *Bureau of Public Secrets*. Translated by Ken Knabb. http://www.bopsecrets.org/CF/graffiti.htm.

McMorrough, John. "City of Shopping: Post-mall Urbanism." In *Harvard Design School Guide to Shopping*, edited by Chuihua Judy Chung, Jeffrey Inaba, Rem Koolhaas, and Sze Tsung Leong, 193–203. Project on the City 2. Cologne: Taschen; Cambridge, MA: Harvard Design School, 2001.

McRae, Carmen. "It's Over Now." *Carmen Sings Monk*. Novus Records, 1988, compact disc.

Moore, William C. *Wall Street: Its Mysteries Revealed, Its Secrets Exposed; Together with a Complete Course of Instruction in Speculation and Investment and Rules for Safe Guidance Therein*. New York: Moore William, 1921.

Muybridge, Eadweard. *The Human Figure in Motion*. London: Chapman and Hall, 1907.

Nash, Ogden. "Spring Comes to Murray Hill," *New Yorker*, May 3, 1930: 26.

Oettermann, Stephan. *The Panorama: History of a Mass Medium*. Translated by Deborah Lucas Schneider. New York: Zone Books, 1997.

Paris, Jean. *L'Espace et le regard*. Paris: Éditions du Seuil, 1965. Translated by Mary Ann Caws. In *The Eye in the Text: Essays on Perception, Mannerist to Modern*, 57. Princeton, NJ: Princeton University Press, 1981.

"Paris Massacre of 1961." Wikipedia. Last modified March 13, 2016. https://en.wikipedia.org/wiki/Paris_massacre_of_1961.

Poster, Mark, and David Savat. *Deleuze and New Technology*. Deleuze Connections. Edinburgh: Edinburgh University Press, 2009.

Pound, Ezra. "Canto C." In Ezra Pound, *The Cantos of Ezra Pound*, 738. Rev. ed. London: Faber and Faber, 1975.

Public Image Ltd. "Fodderstompf." *Public Image: First Issue*. Virgin Records V2114, 1978, LP.

Pucci, Suzanne Rodin. "'*Ceci n'est pas . . .*': Negative Framing in Diderot and Magritte." *Mosaic* 20, no. 3 (Summer 1987): 1–14.

Pynchon, Thomas. *Gravity's Rainbow*. New York: Penguin Books, 1973.

Reich, Steve. "Come Out." *New Sounds in Electronic Music*. Columbia Records / Odyssey Records, 1966, LP.

Ribemont-Dessaignes, Georges. *Dada: Manifestes, Poemes, Articles, Projets, 1915–1930*. Edited by Jean-Pierre Begot. Projectoires. Paris: Champ Libre, 1974. Republished in Stephen C. Foster and Rudolf E. Kuenzli, eds., *Dada Spectrum: Dialectics of Revolt* (Madison: Coda Press; Iowa City: University of Iowa, 1979).

Rivenburg, Roy, "The Boredom Epidemic." *Fort Worth Star-Telegram*, March 1, 2003, 1F, 5F.

Ross, Alex. *The Rest Is Noise: Listening to the Twentieth Century*. New York: Picador / Farrar, Straus and Giroux, 2007.

Sadek, Hakim. "35 Years Ago the 'Battle of Paris': When the Seine Was Full of Bodies." *Liberté*, October 17, 1998, www.fantompowa.net/algerians_liberte.htm.

Saroyan, Aram. "Lightht (1968)." In *Complete Minimal Poems*, 31. Lost Literature Series. New York: Ugly Duckling Presse, 2007.

Schefer, Jean Louis. *Scénographie d'un Tableau*. Collection Tel Quel. Paris: Éditions du Seuil, 1969. Translated by Mary Ann Caws. In *The Eye in the Text: Essays on Perception, Mannerist to Modern*. Princeton, NJ: Princeton University Press, 1981.

Sebbar, Leïla. *La Seine Était Rouge: Paris, Octobre 1961; Roman*. Babel 979. Arles: Actes Sud, 2009.

Sekula, Allan. *Fish Story*. 2nd rev. English ed. Exhibition catalogue. Düsseldorf: Richter Verlag, 2002.

Sélavy, Rrose [Marcel Duchamp]. "Men before the Mirror." In *The Writings of Marcel Duchamp*, edited by Michel Sanouillet and Elmer Peterson, 188–89. New York: Da Capo Press, 1989.

Skoller, Jeffrey. *Shadows, Specters, Shards: Making History in Avant-Garde Film*. Minneapolis: University of Minnesota Press, 2005.

Smithson, Robert. "Aerial Art (1969)" and "Incidents of Mirror-Travel in the Yucatán (1969)." In *The Collected Writings*, edited by Jack Flam, 116–33. Berkeley: University of California Press, 1996.

Solt, Mary Ellen. "Lilac (1963) [from the portfolio *Flowers in Concrete*]." In *Toward a Theory of Concrete Poetry*, edited by Antonio Sergio Bessa, 41. *OEI* 51. Stockholm: *OEI* Magazine, 2010.

Spicer, Jack. "An Apocalypse for Three Voices." In *My Vocabulary Did This to Me: The Collected Poetry of Jack Spicer*, edited by Peter Gizzi and Kevin Killian, 10–11. Wesleyan Poetry. Middletown, CT: Wesleyan University Press, 2008.

Stäheli, Urs. *Spectacular Speculations: Thrills, the Economy, and Popular Discourse*. Stanford, CA: Stanford University Press, 2013.

Stumpel, Marc. "Facebook Resistance: Augmented Freedom." In *Unlike Us Reader: Social Media Monopolies and Their Alternatives*, edited by Lovink Geert and Miriam Rasch, 274–88. *INC Reader* 8. Amsterdam: Institute of Network Cultures, 2013.

Tarkovsky, Andrey. *Sculpting in Time: Reflections on the Cinema*. Translated by Kitty Hunter-Blair. Austin: University of Texas Press, 1986.

Taussig, Michael. *Walter Benjamin's Grave*. Chicago: University of Chicago Press, 2006.

Terranova, Tiziana, and Joan Donovan. "Occupy Social Networks: The Paradoxes of Using Corporate Social Media in Networked Movements." In *Unlike Us Reader: Social Media Monopolies and Their Alternatives*, edited by Lovink Geert and Miriam Rasch, 296–311. *INC Reader* 8. Amsterdam: Institute of Network Cultures, 2013.

Van Den Berg, Claire. "Technology at the Edge of the Body: An Interview with Lucy McRae." *Vestoj*. http://vestoj.com /technology-at-the-edge-of-the-body-an -interview-with-lucy-mcrae.

Van Der Toorn, Merel. "Opinion; Abject Attraction: The Grotesque in Fashion." *Vestoj*. http://vestoj.com/abject -attraction/#fn1-1344.

Vaneigem, Raoul. *The Revolution of Everyday Life*. Translated by Donald Nicholson-Smith. 2nd rev. ed. Welcombe, England: Rebel Press; Seattle: Left Bank Books, 2001.

Venturi, Robert, Denise Scott Brown, and Steven Izenour. *Learning from Las Vegas: The Forgotten Symbolism of Architectural Form*. Rev. ed. Cambridge, MA: MIT Press, 1977.

Virilio, Paul, and Sylvère Lotringer. *Crepuscular Dawn*. Translated by Mike Taormina. Semiotext(e) Foreign Agents Series. Los Angeles: Semiotext(e), 2002.

Warhol, Andy. "Tuesday, August 30, 1977." In *The Andy Warhol Diaries*, unpaginated. Edited by Pat Hackett. New York: Warner Books, 1989 (PDF e-book).

Wark, McKenzie. "Furious Media: A Queer History of Heresy." In Alexander R. Galloway, Eugene Thacker, and McKenzie Wark, *Excommunication: Three Inquiries in Media and Mediation*, 151–210. Trios. Chicago and London: University of Chicago Press, 2014.

———. *The Beach beneath the Street: The Everyday Life and Glorious Times of the Situationist International*. London and New York: Verso, 2015.

"Well, You Needn't." Wikipedia. Last modified June 1, 2016. https://en.wikipedia.org/wiki /Well,_You_Needn%27t.

Wiener, Allen J. *The Beatles: The Ultimate Recording Guide*. 3rd rev. ed. Holbrook, MA: B. Adams, 1994.

Williams, Linda, *Hard Core: Power, Pleasure, and the "Frenzy of the Visible."* Berkeley: University of California Press, 1989.

Woods, Alan. *Being Naked, Playing Dead: The Art of Peter Greenaway*. Manchester and New York: Manchester University Press, 1996.

Xu, Tan. "Searching for Keywords." In *Visible: Where Art Leaves Its Own Field and Becomes Visible as Part of Something Else*, edited by Angelika Burtscher and Judith Wielander, 168–75. Exhibition catalogue. Berlin and New York: Sternberg Press, 2010.

"'You Don't Need' vs. 'You Needn't.'" Antimoon. http://www.antimoon.com/forum /t10532-15.htm.

Young, La Monte, and Marian Zazeela. "Dream House." In *Selected Writings*, 10–17. New York: Ubuclassics, 2004.

Zielinski, Siegfried. *Audiovisions: Cinema and Television as Entr'actes in History*. Translated by Gloria Custance. Film Culture in Transition. Amsterdam: Amsterdam University Press, 1999.

Zukofsky, Louis. "Julia's Wild." In *Concrete Poetry: A World View*, edited by Mary Ellen Solt, 219. Bloomington: Indiana University Press, 1970.

Zultanski, Steven. "Self-Portrait for Swimming 2." In *Agony*, 106–10. Toronto: BookThug, 2012.

117

118

Credits and Copyrights

Archival material related to Walter Benjamin and *The Arcades Project* has been selected and presented in collaboration with the Walter Benjamin Archiv, Akademie der Künste, Berlin.

Front cover: Passage des Panoramas, Paris, 1880–1900, built 1800; and clockwise from left: Erica Baum, *Corpse,* see p. 95; Mary Reid Kelley, *Charles Baudelaire,* see p. 57; Chris Burden, *Tower of London Bridge,* see p. 49; Collier Schorr, *Jennifer (Head),* see p. 41; Raymond Hains, *Martini,* see p. 51. Back cover: Clockwise from lower left: Mungo Thomson, *June 25, 2001 (How the Universe Will End) March 6, 1995 (When Did the Universe Begin?),* see p. 73; Jesper Just, *Intercourses,* see p. 43; Martín Ramírez, Untitled (*Trains and Tunnels*), A, B, see p. 79; Andreas Gursky, *Chicago Mercantile Exchange,* see p. 97; Walead Beshty, *Randall Park Mall (View of Escalator), North Randall, OH, Est. 1976, Demo. 2014,* see p. 39. Inside back cover: The Convolutes, page from Benjamin's notes for *The Arcades Project,* see p. 37; Claire Fontaine, *The Barricades of May Brickbat,* see p. 47. Page 1: Passage Choiseul, Paris, c. 1910, built 1827.

Inside back cover and pages 14–15, 16, 37, 117: Mss. 284/17, 284/29, 284/43, 284/49, 64, 2001, 324, pp. 15v–16r, © Hamburger Stiftung zur Forderung von Wissenschaft und Kultur / Akademie der Künste, Walter Benjamin Archiv. 1, 11: Photograph by LL, image provided by Roger-Viollet / Image Works. 19: Image provided by the Metropolitan Museum of Art, New York. 22–23: Photograph © Gisèle Freund, and the Institut Mémoires de l'Edition Contemporaines (IMEC), Fonds MCC; image provided by the RMN-Grand Palais / Art Resource, New York. 27: Image provided by the Metropolitan Museum of Art, New York. 28 left: Image provided by the Manuscript Division, Sigmund Freud Papers, Sigmund Freud Collection, Library of Congress, Washington, DC. 28 right: Permission provided by the Marsh Agency, Ltd, London, on behalf of Sigmund Freud Copyrights; image provided by Caroline A. Jones. 31: Philadelphia Museum of Art, 125th Anniversary Acquisition, the Lynne and Harold Honickman Gift of the Julien Levy Collection, 2001; image provided by Bridgeman Images, New York. 34, 91: Artworks © Adam Pendleton; images provided by Studio Pendleton, Brooklyn, New York. 39: Artwork © Walead Beshty; image provided by Regen Projects, Los Angeles. 41: Artwork © Collier Schorr; image provided by 303 Gallery, New York. 43: Artwork © Jesper Just; image provided by the artist and James Cohan Gallery, New York. 45: Artworks © Guido van der Werve; images

provided by Luhring Augustine, New York. 47: Artwork © Studio Claire Fontaine; photograph by James Thornbill, image provided by Air de Paris, Paris, and Claire Fontaine. 49: Artwork © Chris Burden Studio; image provided by the Chris Burden Estate and Gagosian. 51: Artwork © Raymond Hains; image provided by Galerie Max Hetzler, Paris. 53: Artwork © Cindy Sherman; image provided by Metro Pictures, New York. 55: Artwork © Simon Evans; photograph by Christopher Burke, image provided by James Cohan Gallery, New York. 57: Artwork © Mary Reid Kelley; image provided by Fredericks & Freiser Gallery, New York. 59: Artwork © Mike Kelley Foundation for the Arts; All Rights Reserved / Licensed by VAGA, New York. 61: Artwork © James Welling; image provided by Regen Projects, Los Angeles. 63: Artworks © Lee Friedlander; images provided by Fraenkel Gallery, San Francisco. 65: Artworks © Taryn Simon. 67: Artwork © Rodney Graham; image provided by Kadist, San Francisco. 69: Artwork © Jorge Macchi; image provided by Jorge Macchi. 71: Artwork © Nicholas Buffon; image provided by Callicoon Fine Arts, New York. 73: Artwork © Mungo Thomson; image provided by Kadist, San Francisco. 75: Artwork © Sanya Kantarovsky; photograph by Andy Keate, image provided by Sanya Kantarovsky and her studio. 77: Artwork © Cerith Wyn Evans; photograph by Todd-White Art Photography, image provided by White Cube, London. 79: Artwork © the Estate of Martín Ramírez; image provided by Ricco Maresca Gallery, New York. 81: Artwork © Voluspa Jarpa; image provided by Mor Charpentier, Paris. 83: Artwork © Joel Sternfeld; image provided by Luhring Augustine, New York. 85: Artworks © Milena Bonilla; images provided by Kadist, San Francisco. 87: Artwork © Tim Lee; image provided by Lisson Gallery, London. 89: Artwork © Markus Schinwald; image provided by Markus Schinwald. 93 top: Artwork © Walker Evans Archive, Metropolitan Museum of Art; image provided by Museum of Modern Art / Licensed by Scala / Art Resource, New York. 93 bottom: Artwork © Walker Evans Archive, Metropolitan Museum of Art; image provided by Art Resource, New York. 95: Artworks © Erica Baum; images provided by Bureau, New York. 97: Artwork © Andreas Gursky; image provided by Colleción Isabel y Agustín Coppel (CIAC), Mexico City. 99: Artwork © Timm Ulrichs and VG Bild-Kunst, Bonn; image provided by Wentrup, Berlin. 101: Artwork © Andrea Bowers; photograph by Robert Wedemeyer, image provided by Susanne Vielmetter Los Angeles Projects, Culver City, CA. 103: Artwork © Haris Epaminonda and

120